Four Seasons of Fairies and Flowers

A Coloring Book
for
The Young At Heart

Lisa R Davis

Cover fairy trio colored by Teagan C Davis

Copyright © 2016 Lisa R Davis

All rights reserved. No part of this book may be reproduced or transmitted in any form or by any means, electronic or mechanical, including photocopying, recording, or by any information storage or retrieval system, without permission from the author of this book. But feel free to frame your finished work of art!

ISBN-13: 978-1537350943
ISBN-10: 1537350943

Contained in this Book:

- 51 artworks from the four seasons to color
- For a variety of coloring experiences, there are a mixture of images: outlined, grayscale, fairies, flowers, and some designs with both fairies and flowers
- Designs range in complexity from beginner to expert-level
- The pages are 8.5 X 11, but all designs have been scaled to 7.5 X 9.5 to fit into an 8 X 10 frame without covering any of the detail
- Some of the pages have titles at the bottom of the page, below the 10 inch borderline of the image
- Some pages have the flowers in the design listed, but feel free to use your imagination in color choices

Coloring Tips:

- Use your medium of choice: colored pencils, felt-tip markers, gel pens, combinations, etc.
- The paper in this book is 60 lb; a cardboard blotter should be used between pages.
- For grayscale coloring: cover the heaviest gray areas with your darkest colors and the lightest gray areas with your palest colors to help with tone and shading.
- The printing process can cause streaking in some of the grayscale designs. Coloring will cover most of these.
- There are many on-line guides and tutorials for grayscale coloring, blending, shading, and adding highlights while coloring.
- You can use the next page or the pages at the end to see how your chosen medium looks on this paper.
- Relax and have fun!

Miss Bleeding Heart with her flower

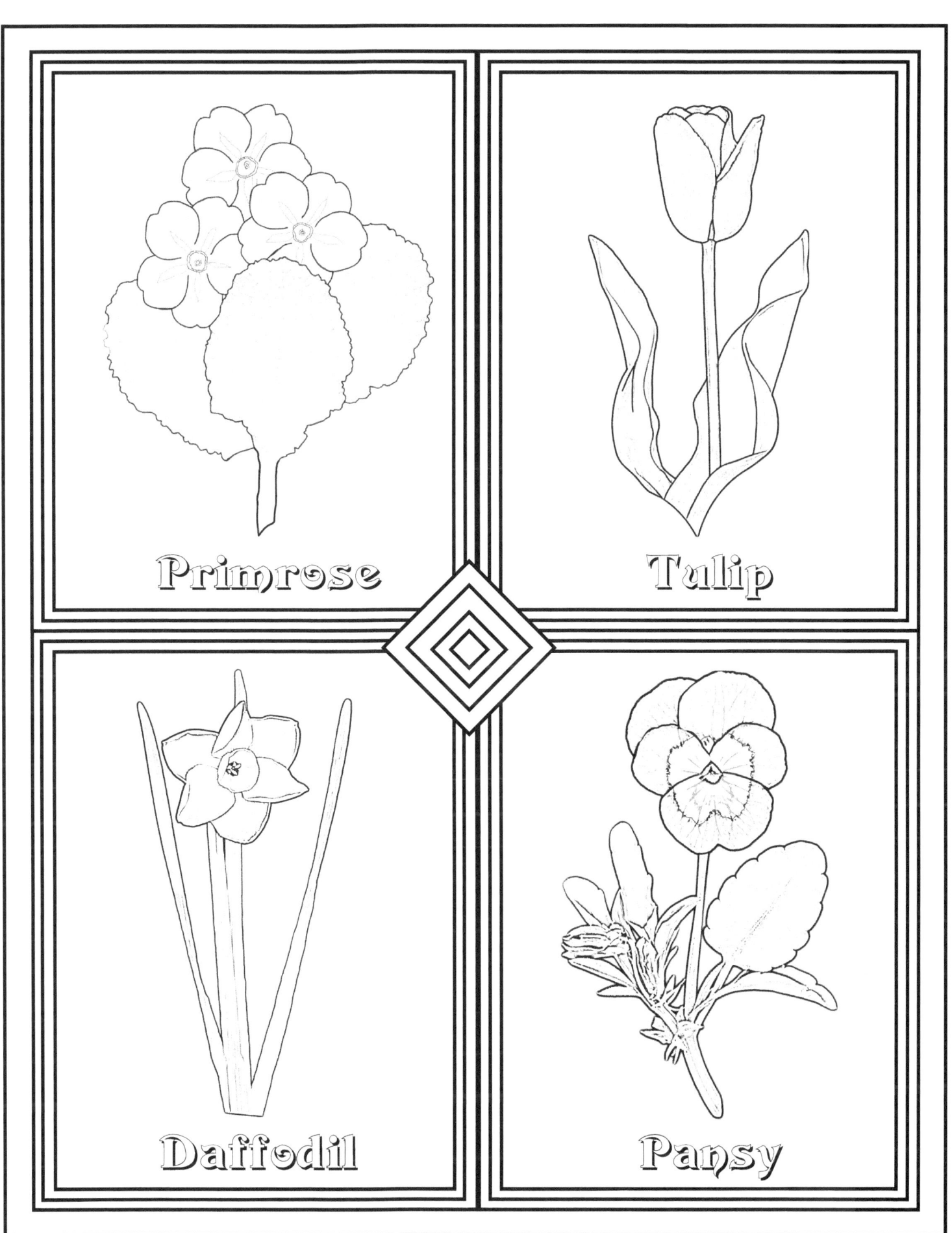

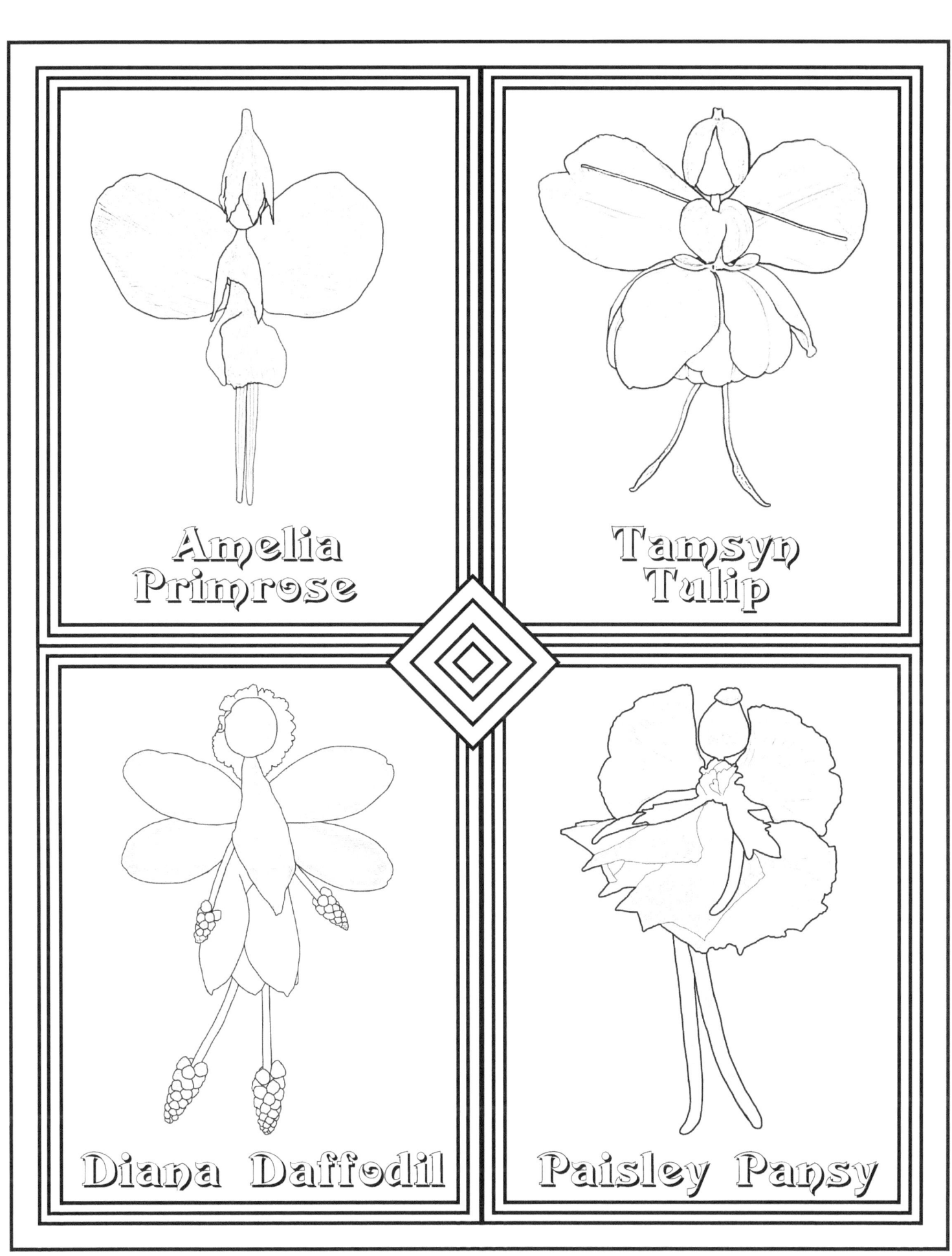

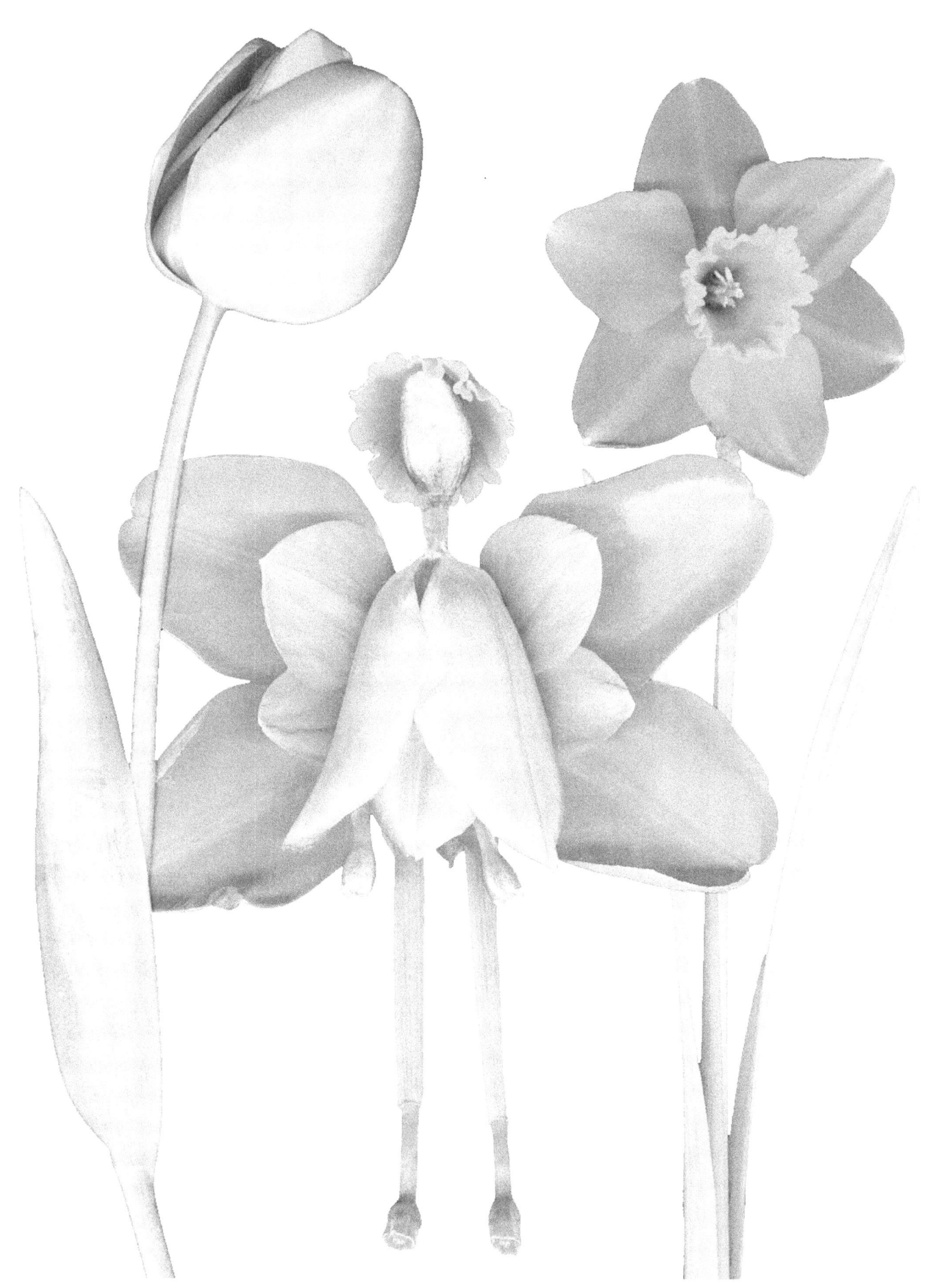

A daffodil/tulip fairy and his flowers

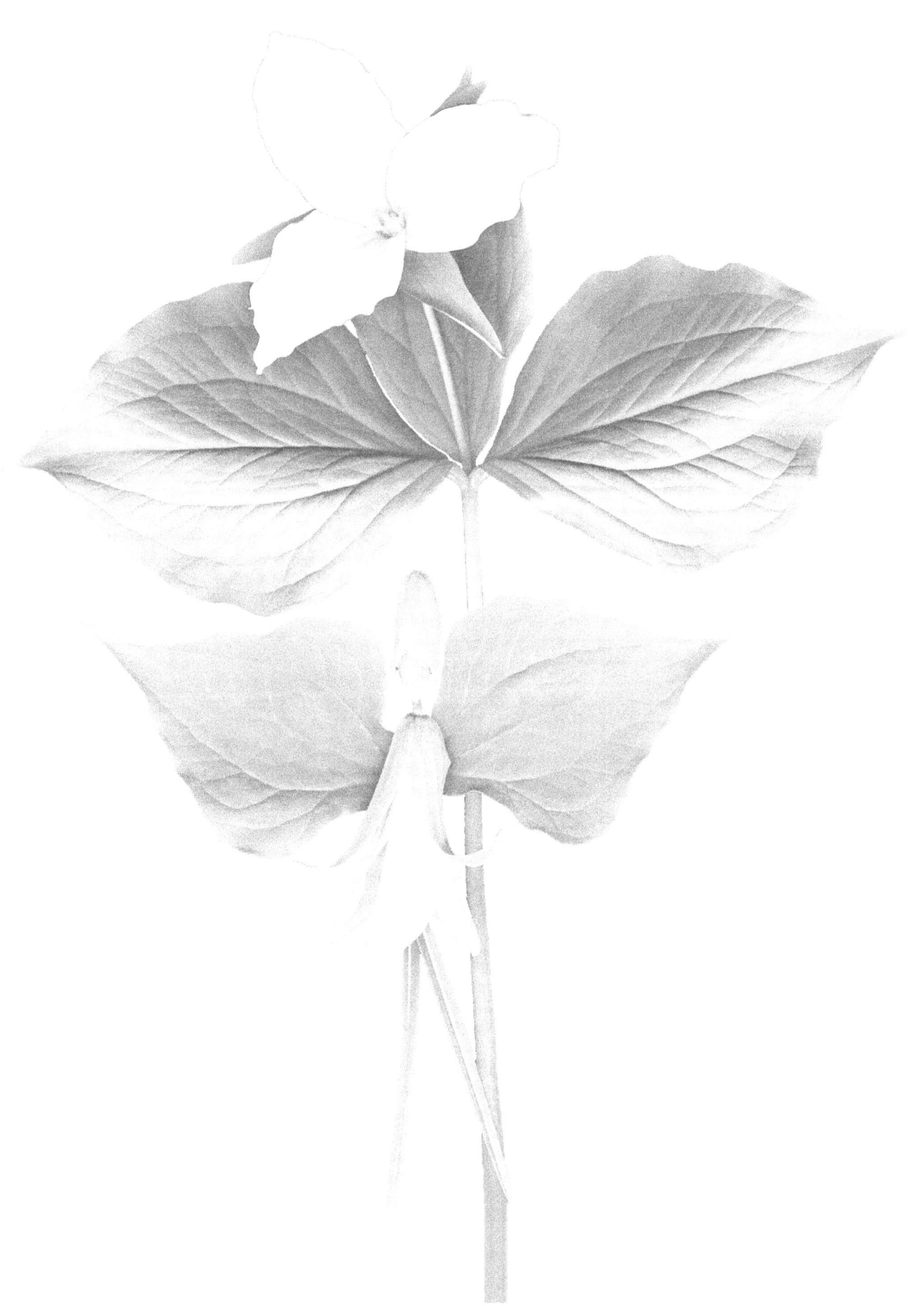

Leah Trillium with her flower

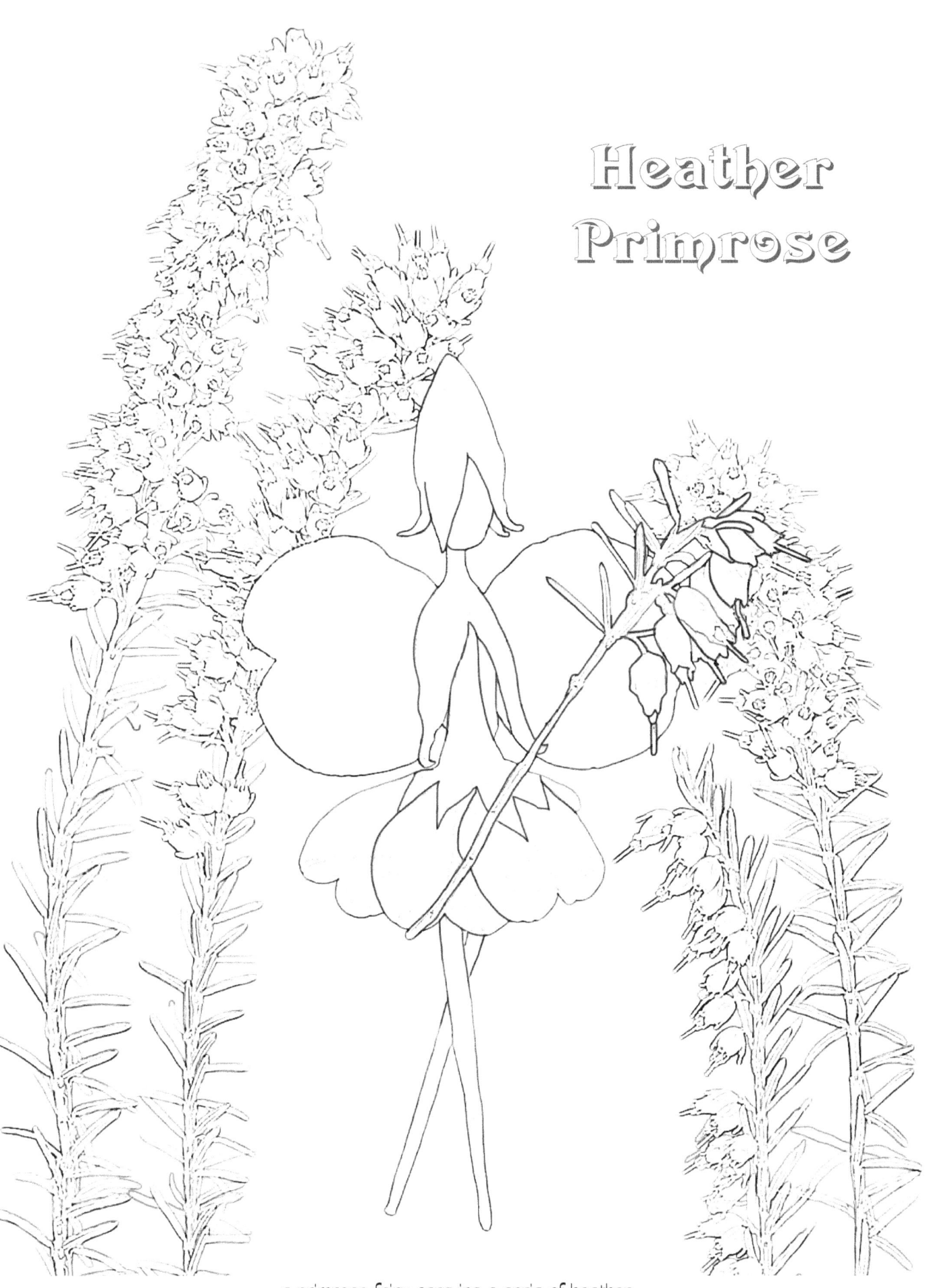

a primrose fairy carrying a sprig of heather

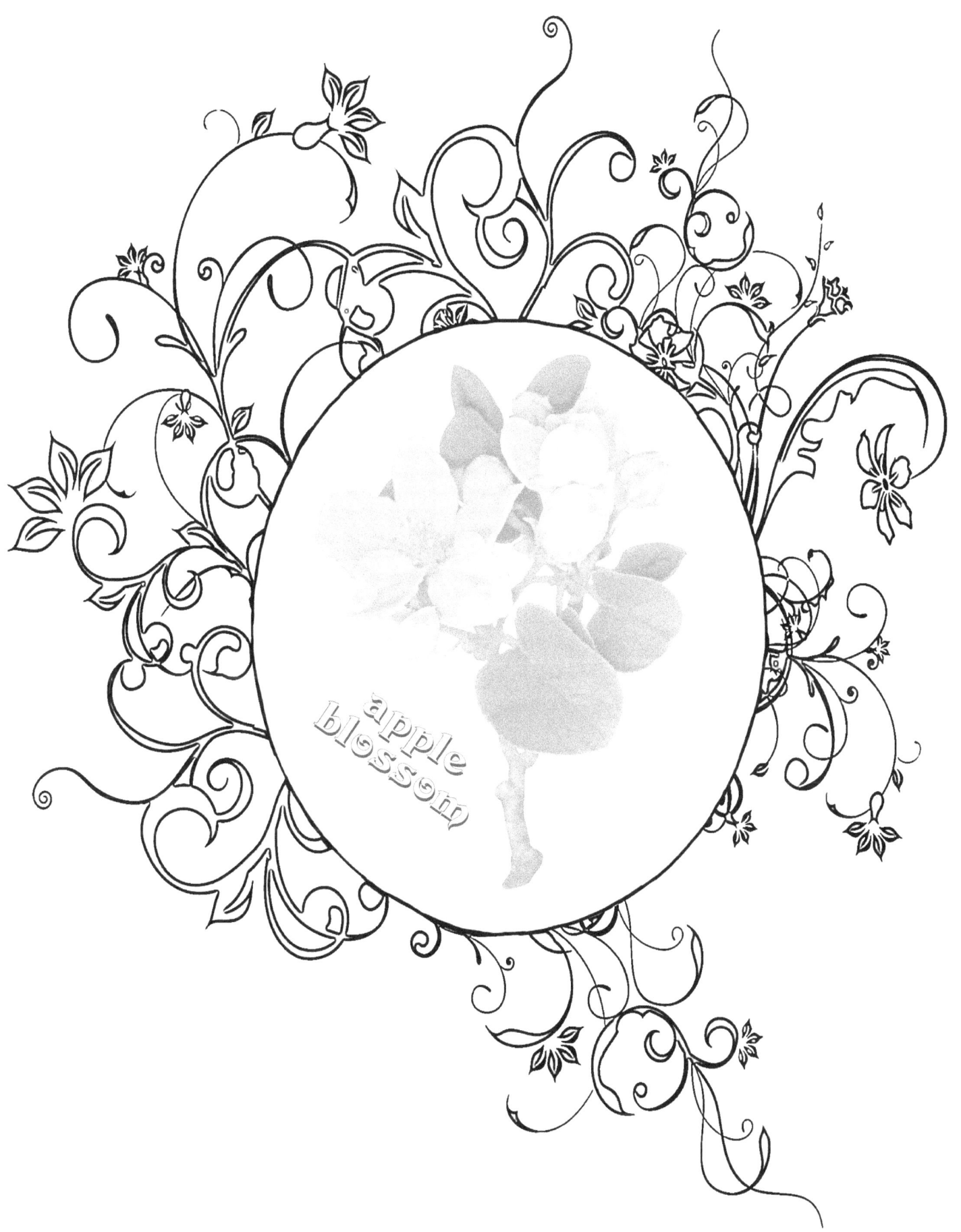

a daffodil trio, grape hyacinth, striped squill, and glory-of-the-snow

a bleeding heart bouquet with phlox, lily-of-the-valley, forget-me-nots, and four fairies

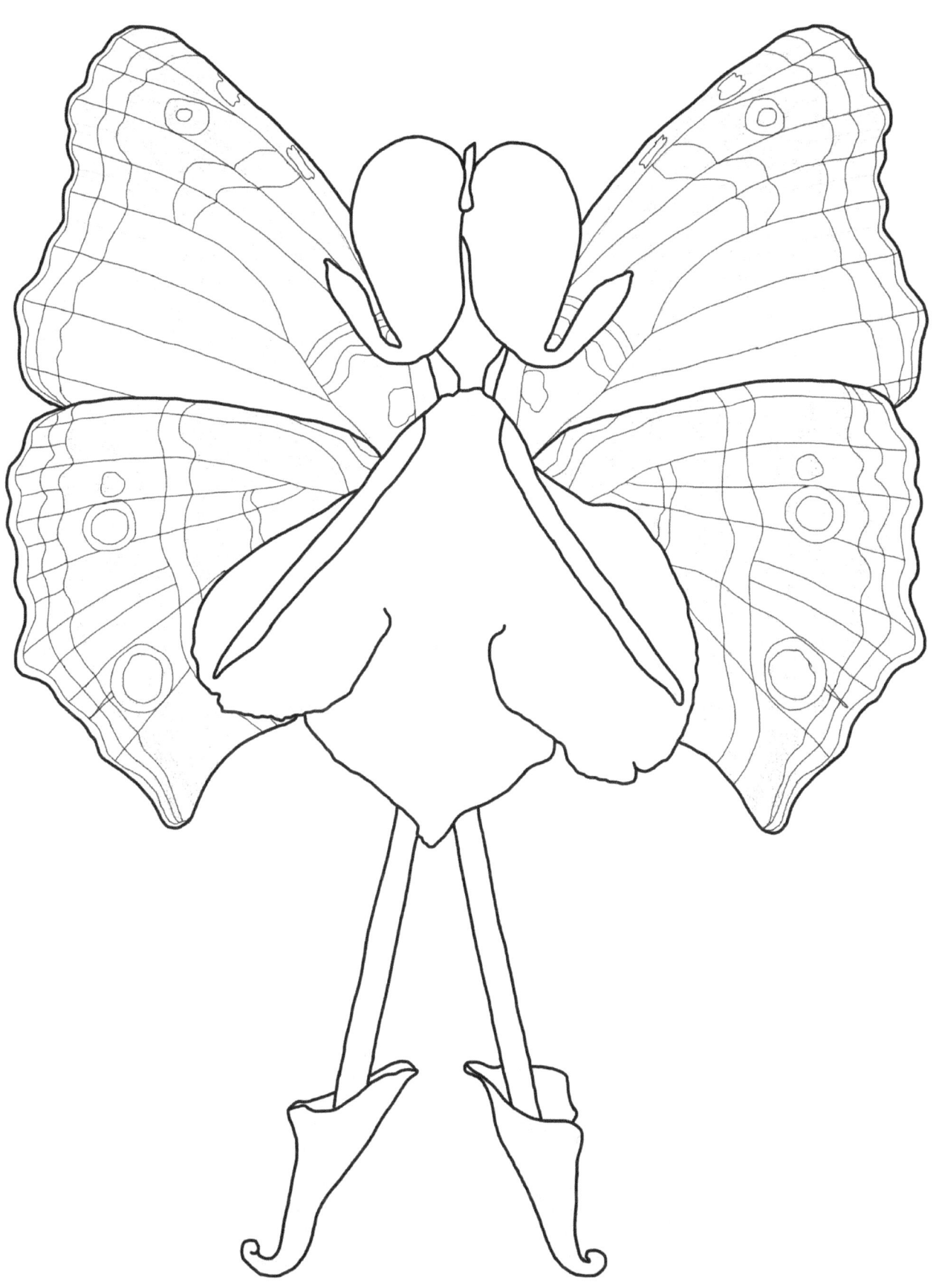

Bethany Bleeding Heart Butterfly

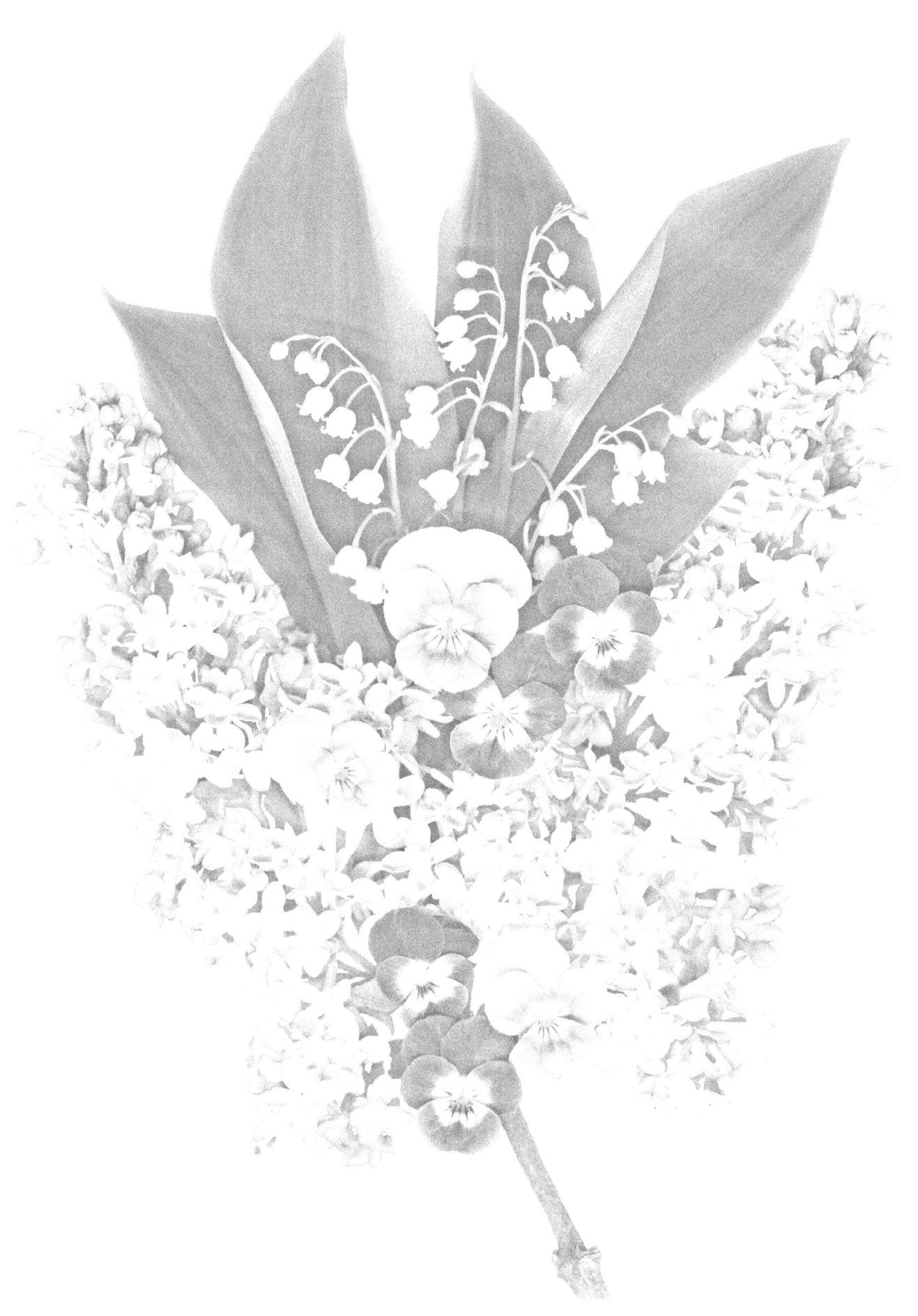

a lilac bouquet with violas and lily-of-the-valley

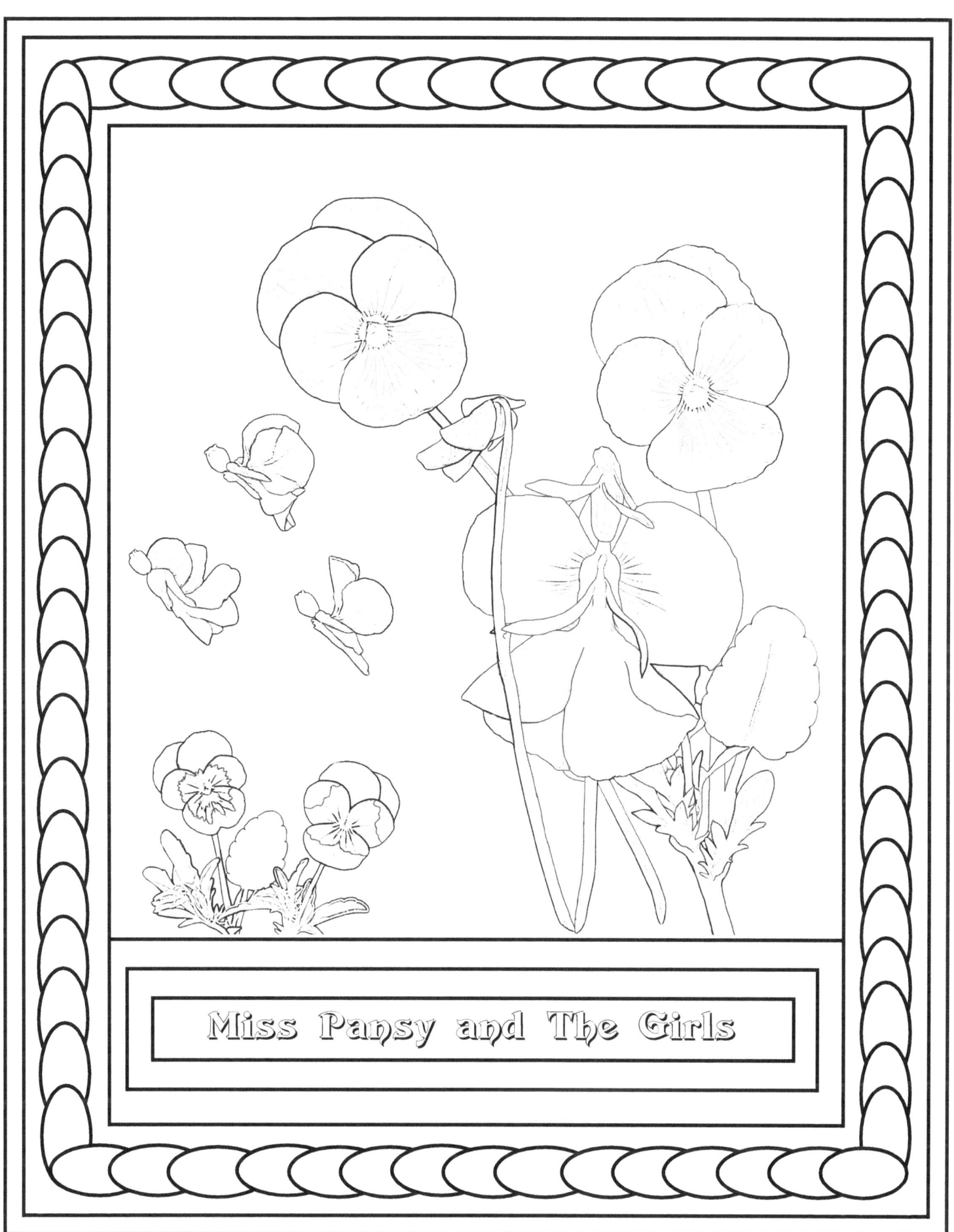

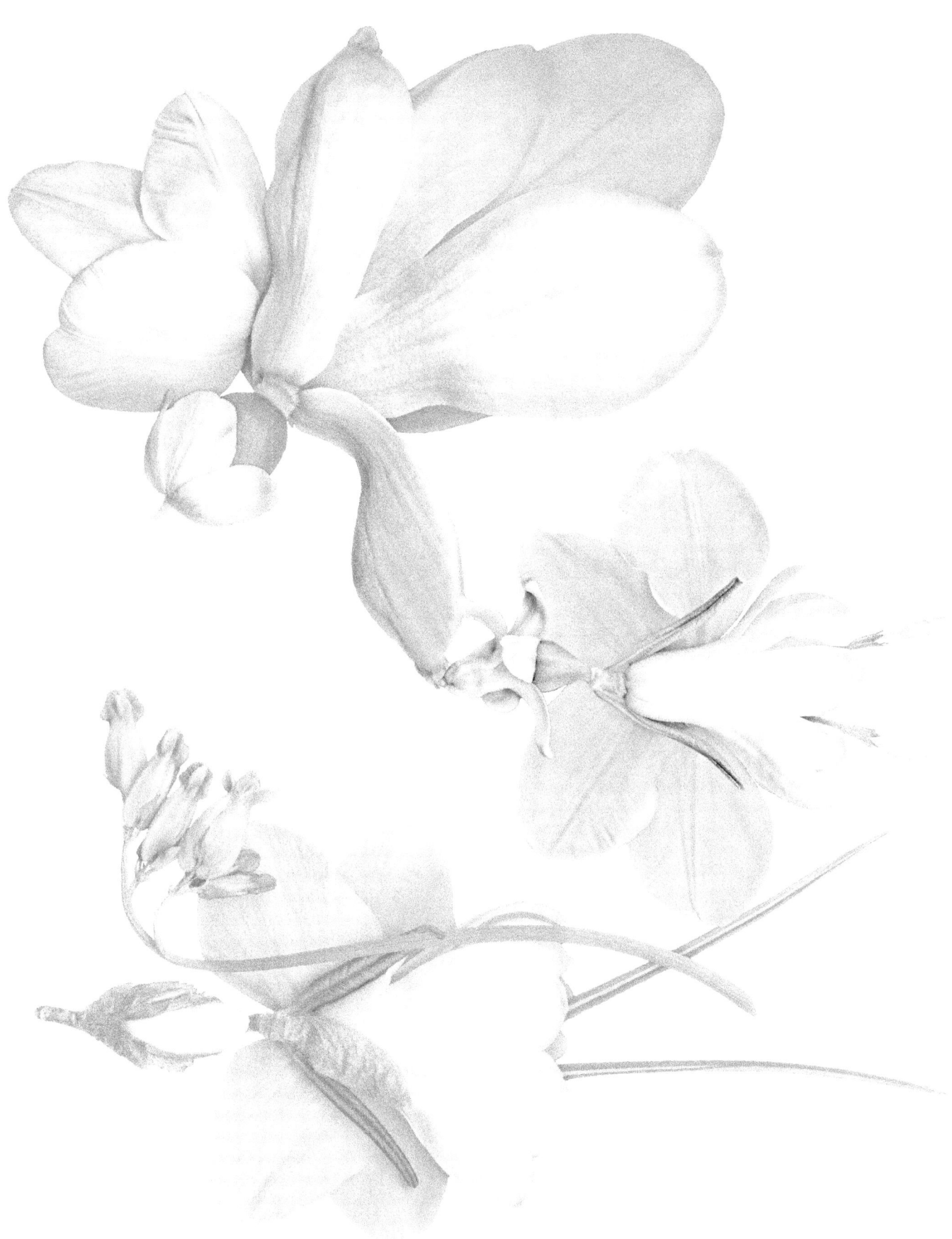

The Magnolia Family

A daylily bouquet with coreopsis

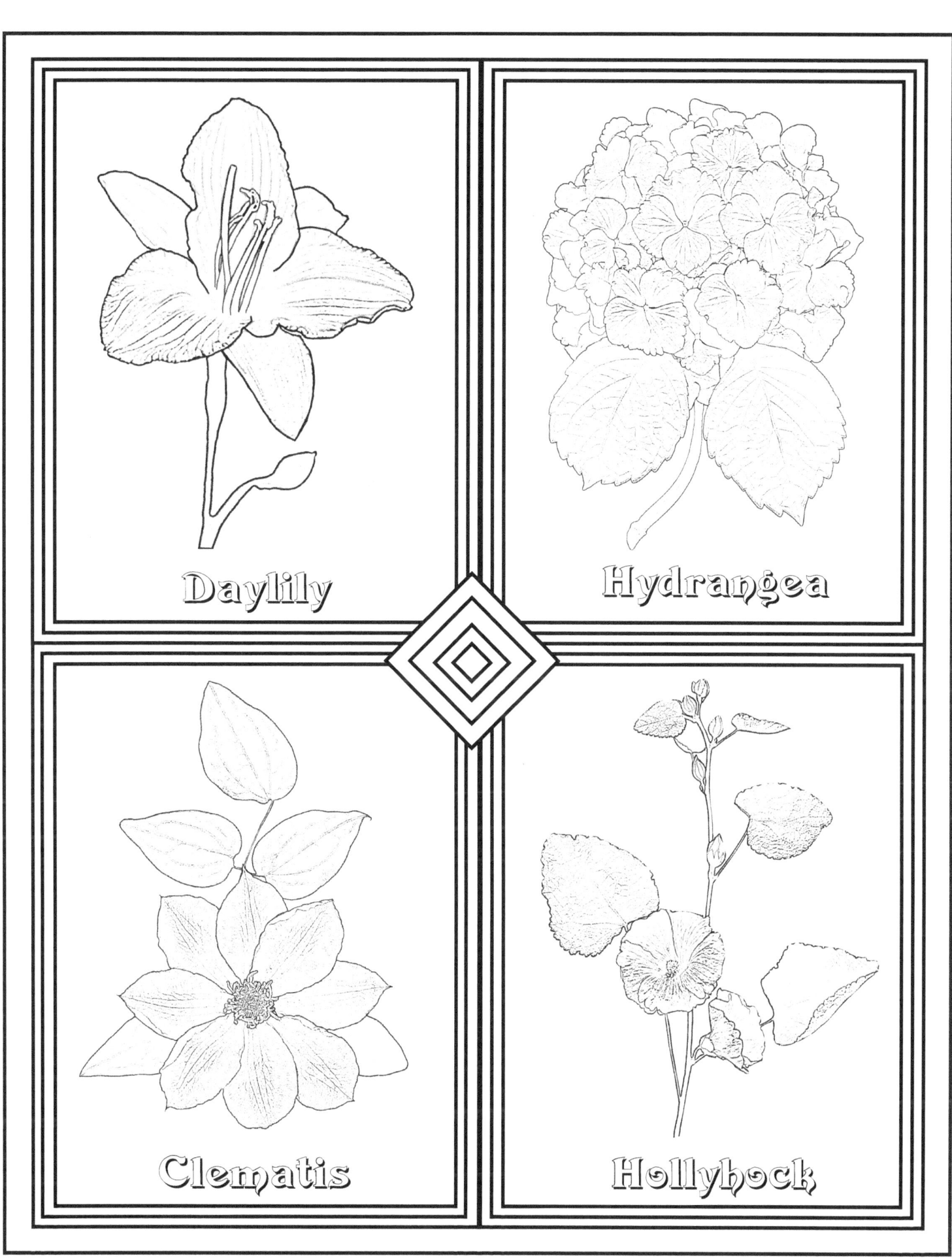

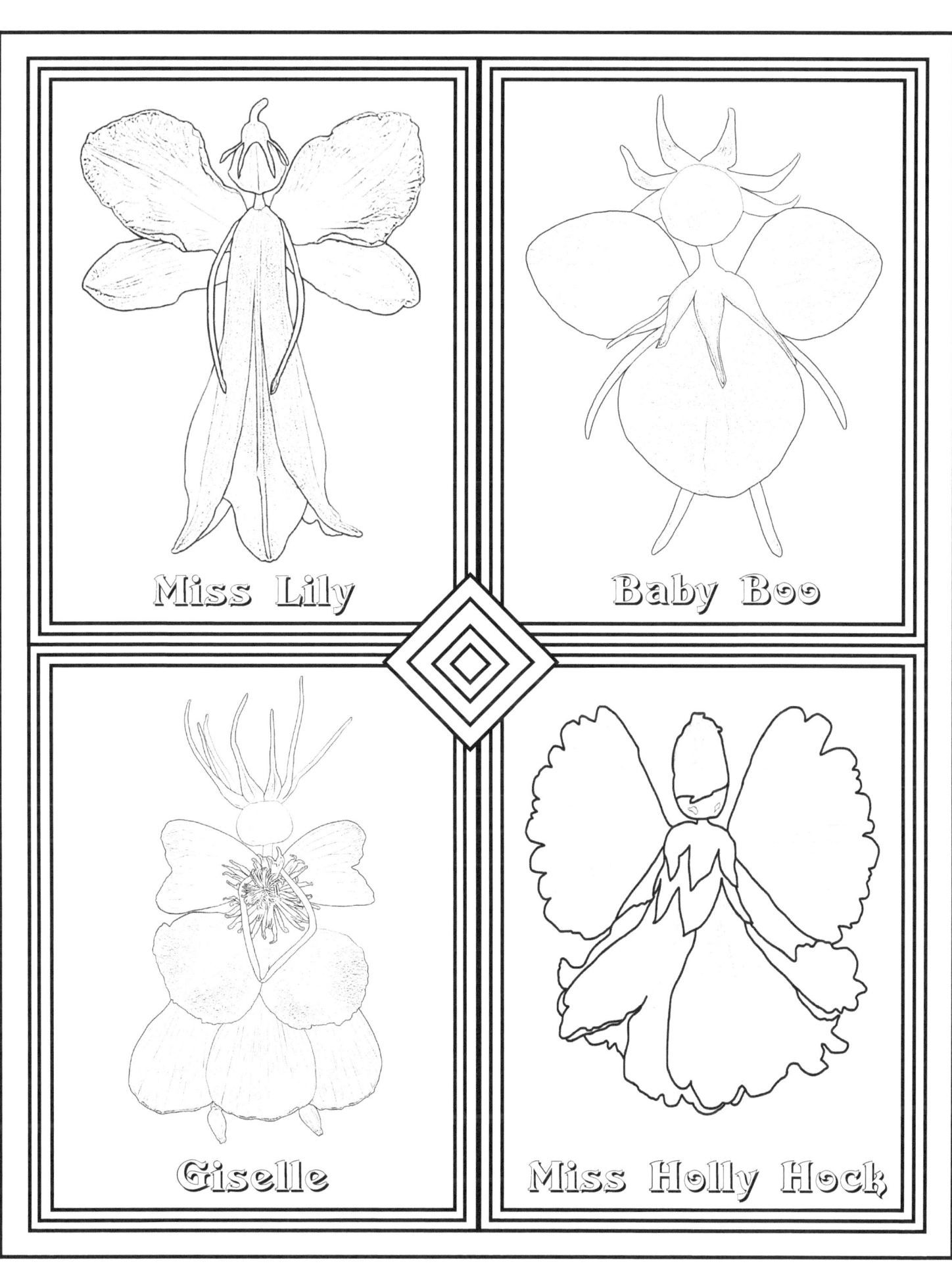

Levi Tiger Lily

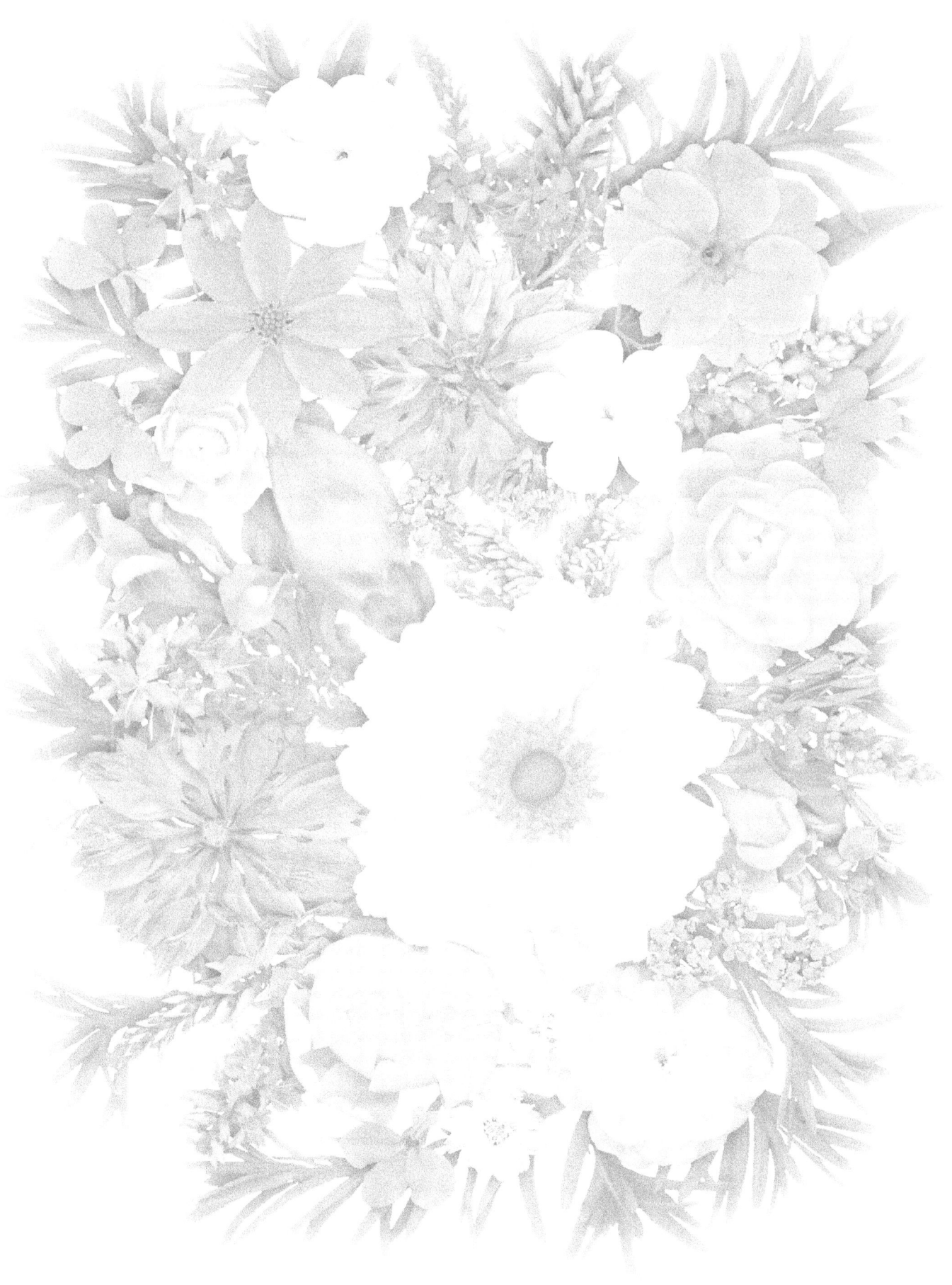

a multi-colored bouquet with a Japanese anemone focal point

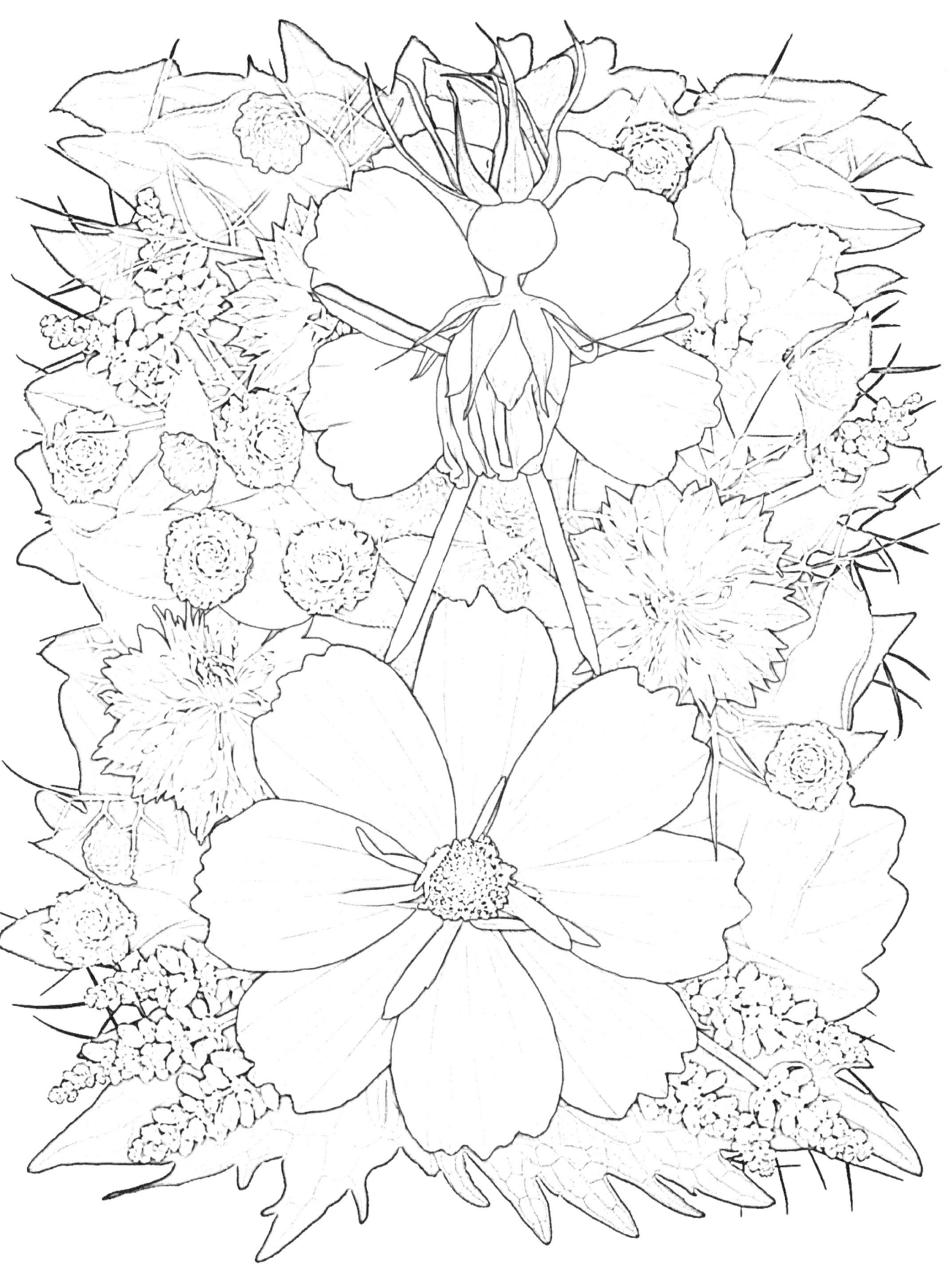

Fairy Fiona in a cosmos bouquet with salvia, globe amaranth, and love-in-a-mist

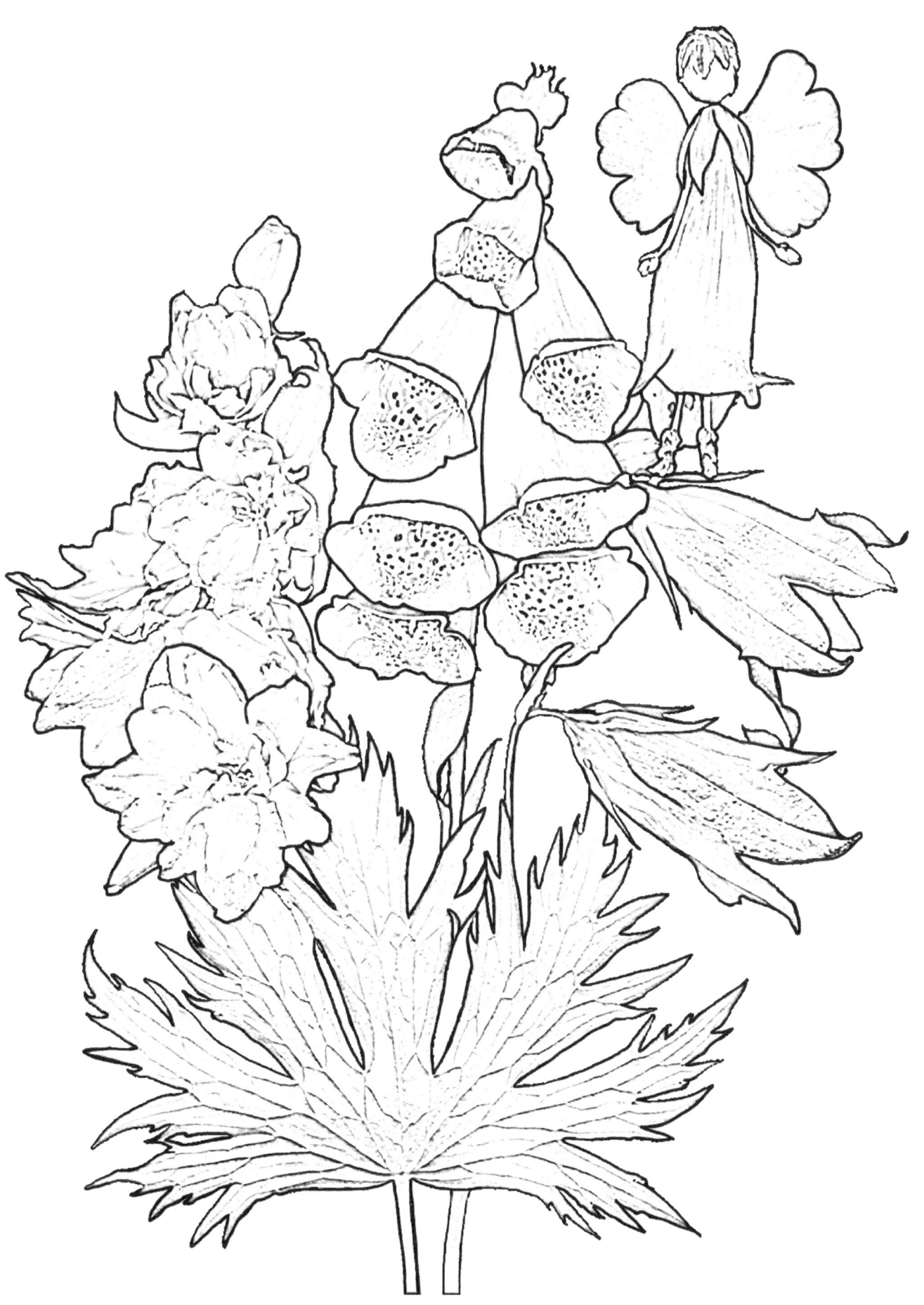

Tess Foxglove in a bouquet with delphinium, foxglove, and bellflower

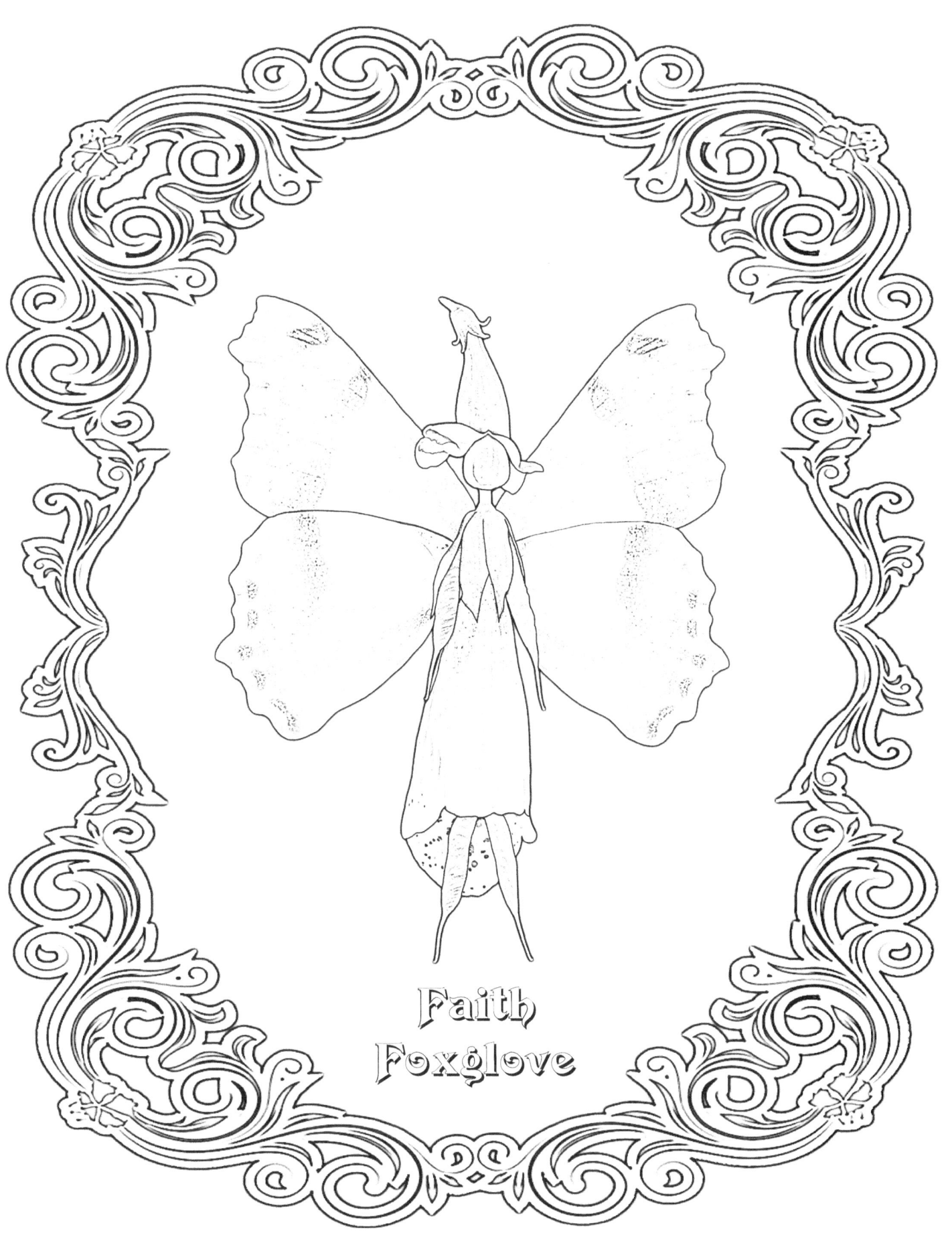

a fairy with a foxglove gown, seedpod arms and legs, a penstemon hat, and butterfly wings

Piper and Pepper — The Rosebud Twins

Fairy Giselle in a bouquet with a cosmos, Japanese anemone, rose, butterfly bush, lavender, and sedum

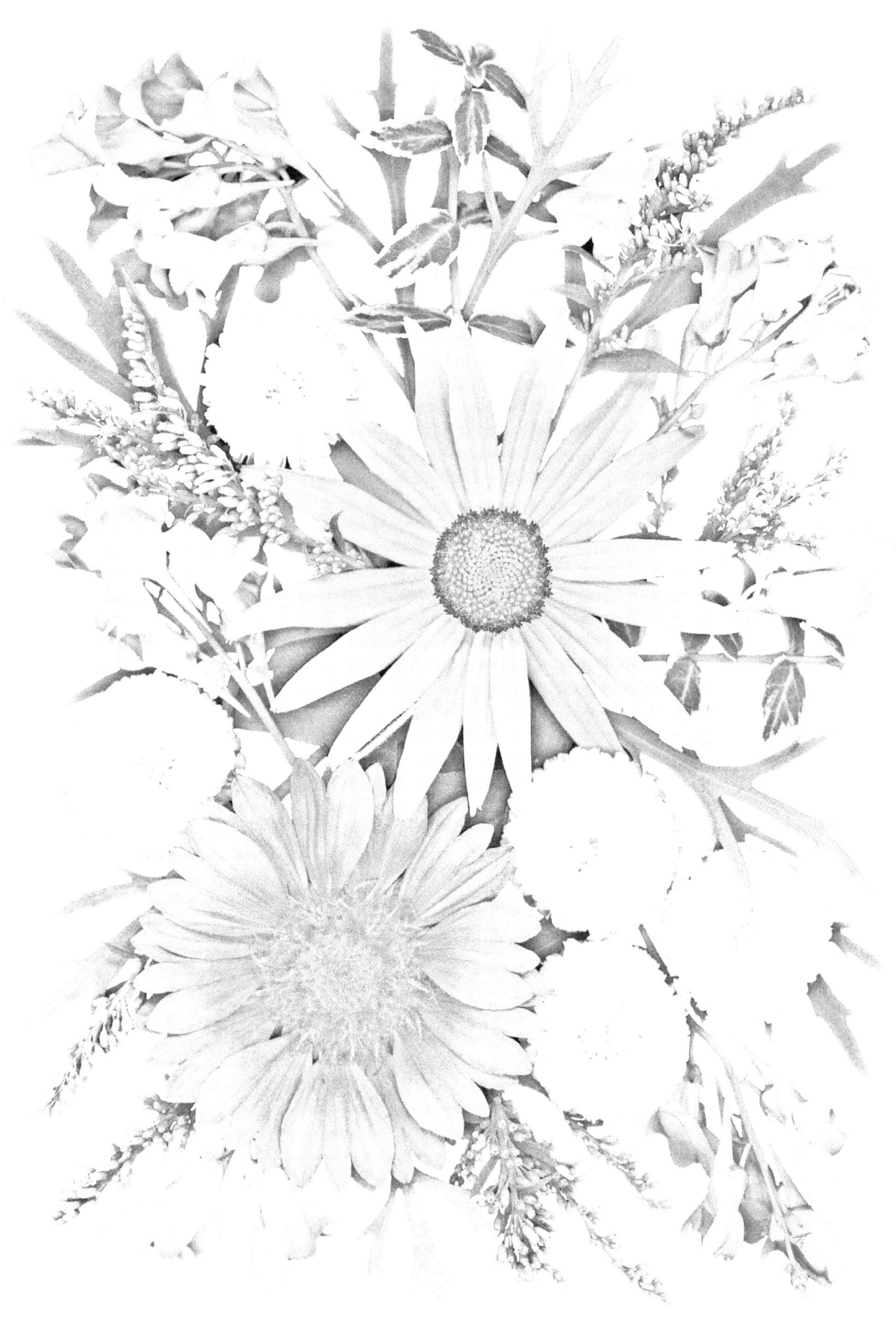

a bouquet with a black-eyed-Susan, burgundy blanket flower, goldenrod, chrysanthemums, and toadflax

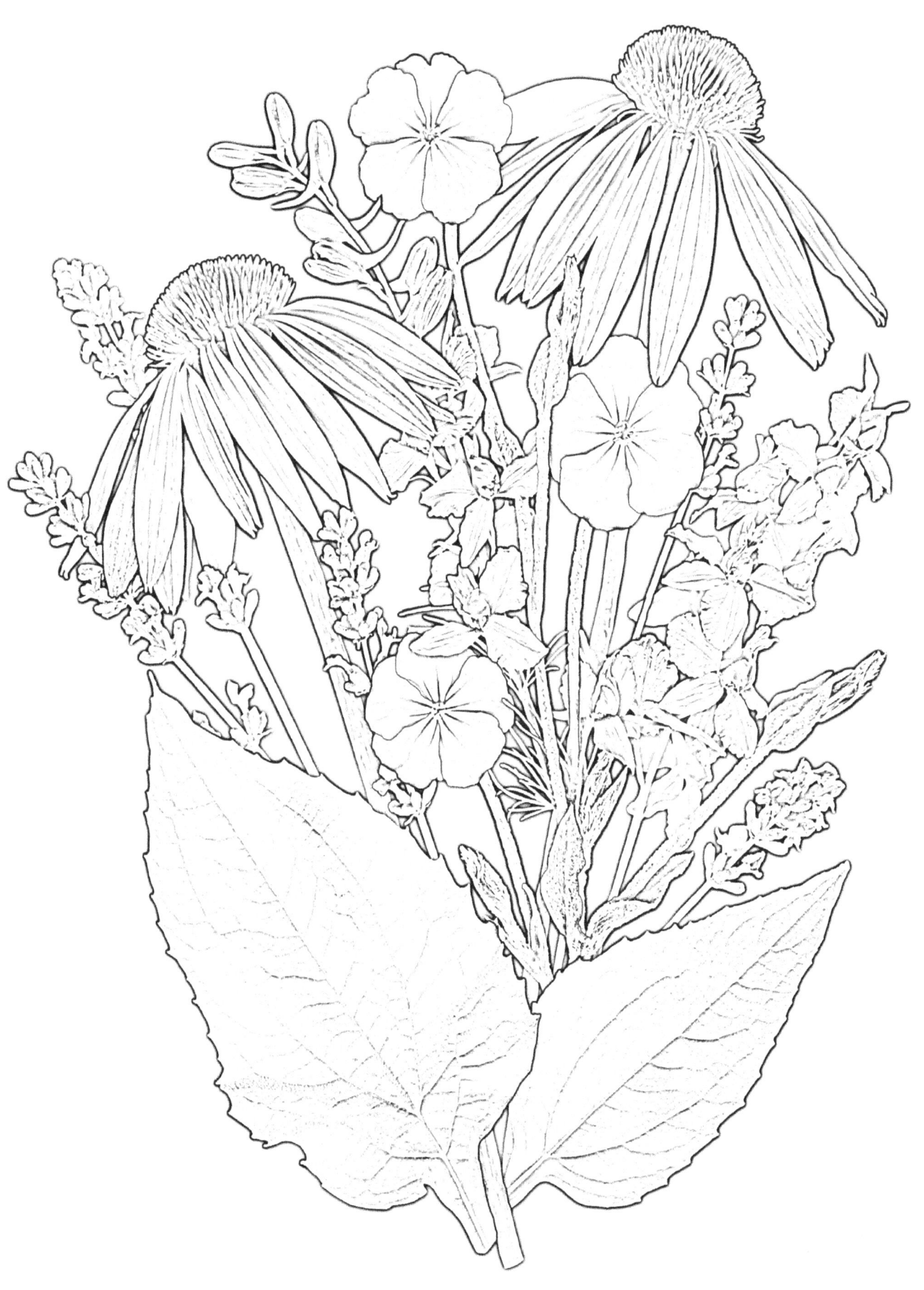

a coneflower bouquet with rose campion, larkspur, and lavender

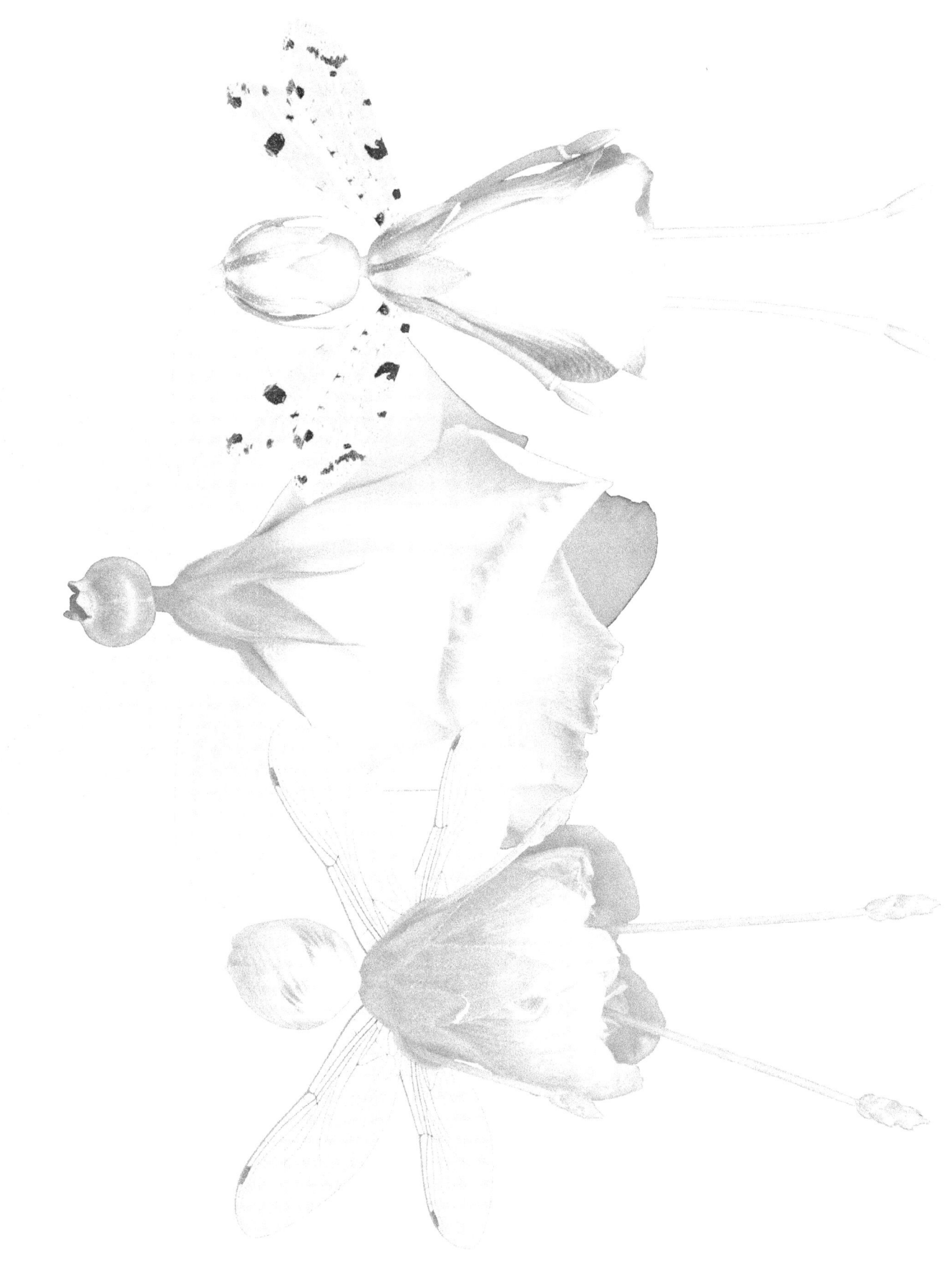

three dragonfly girls: Hannah Hollyhock, Lizzie Anne, and Rosie Sharon

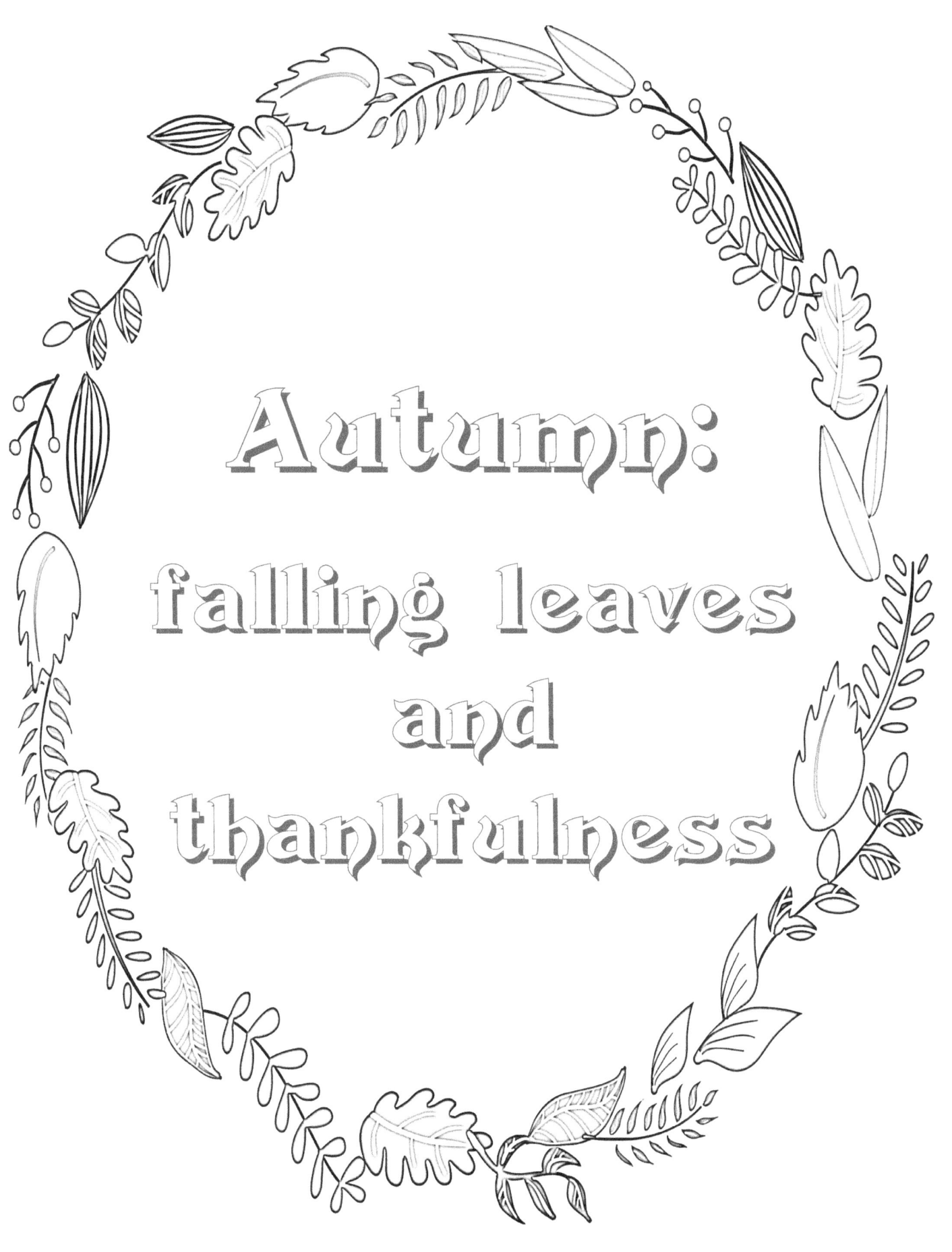

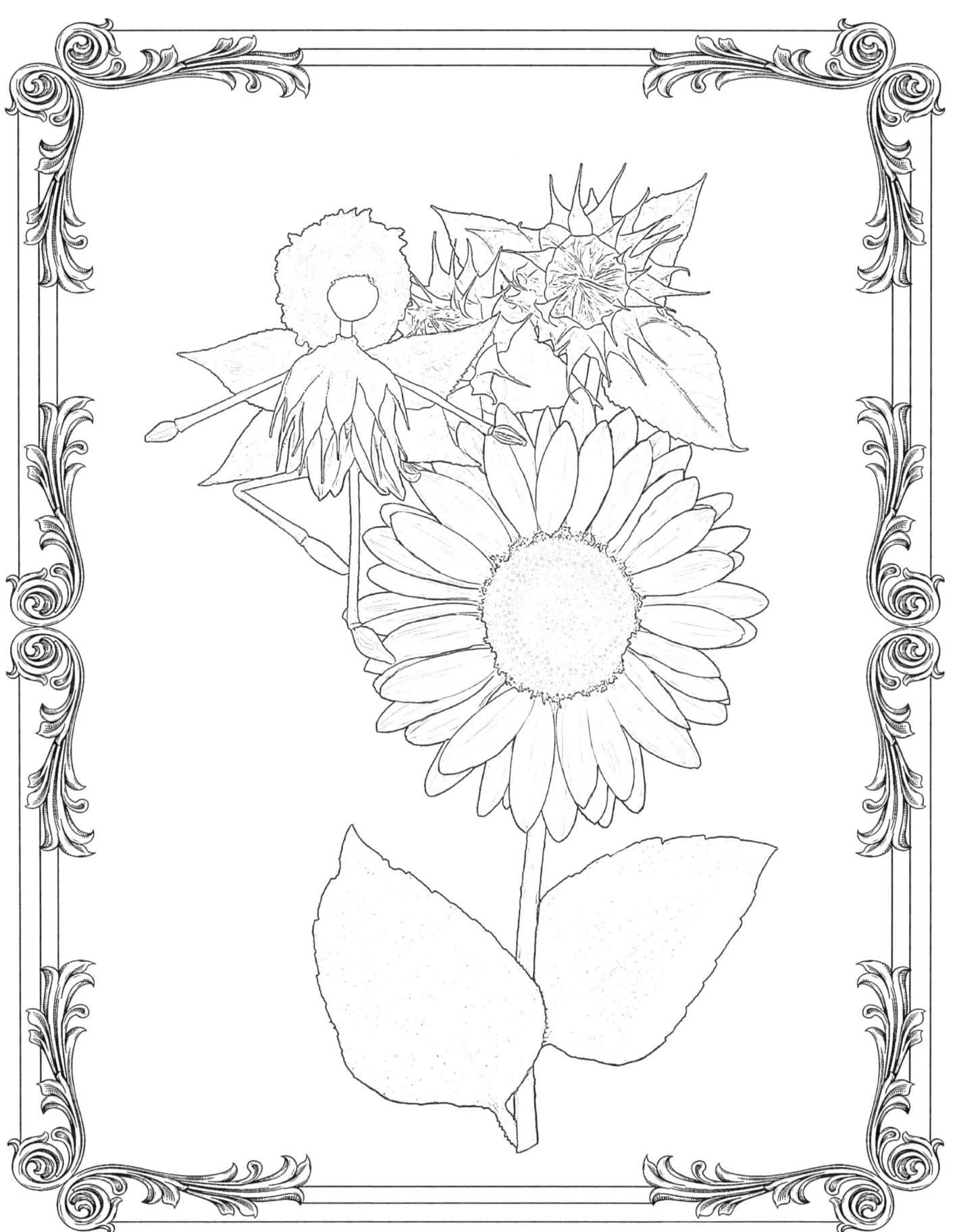

sunflower dancer

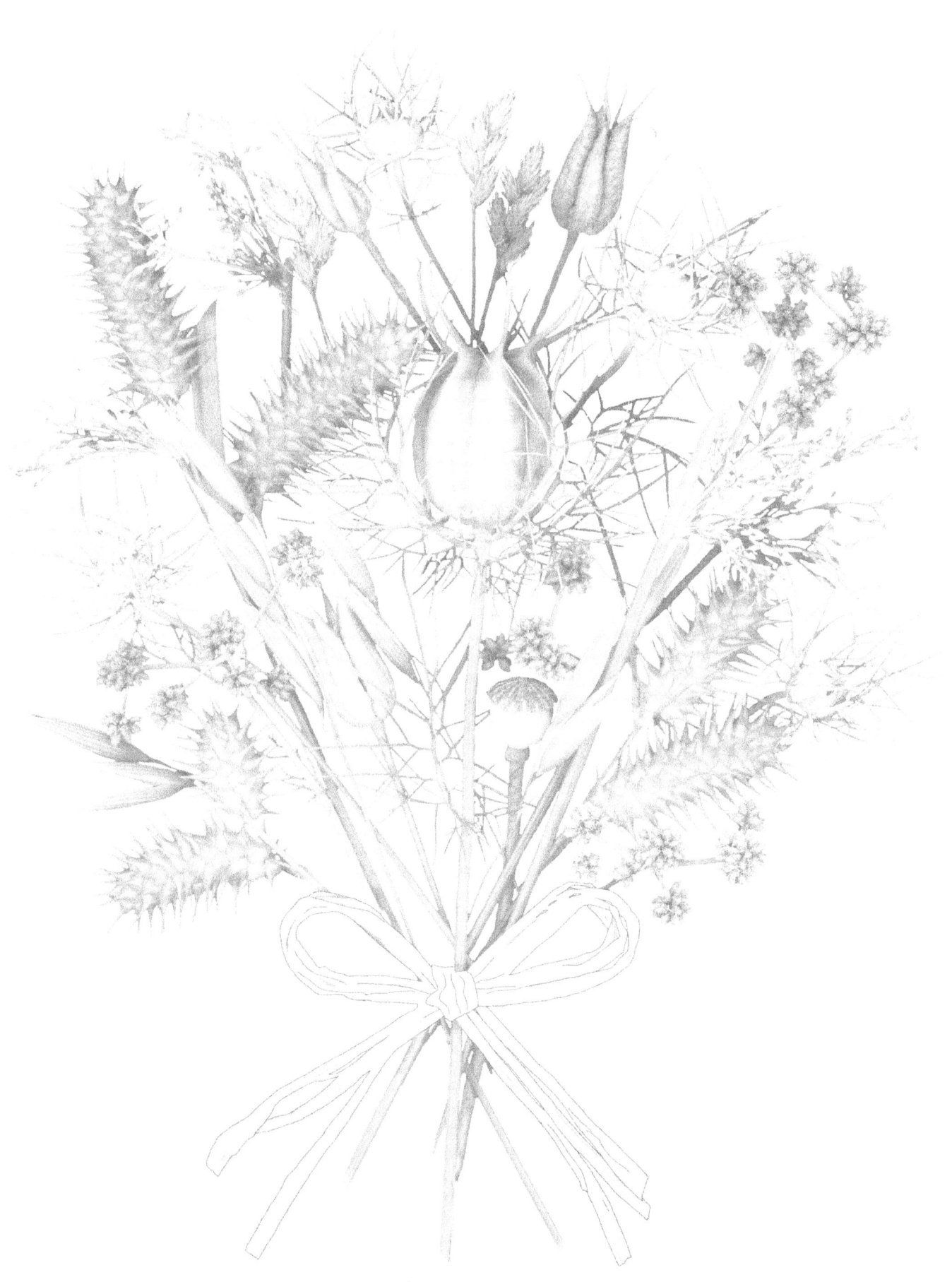

seedpods and grasses

maple leaf with seeds

gourds

autumn maple leaves

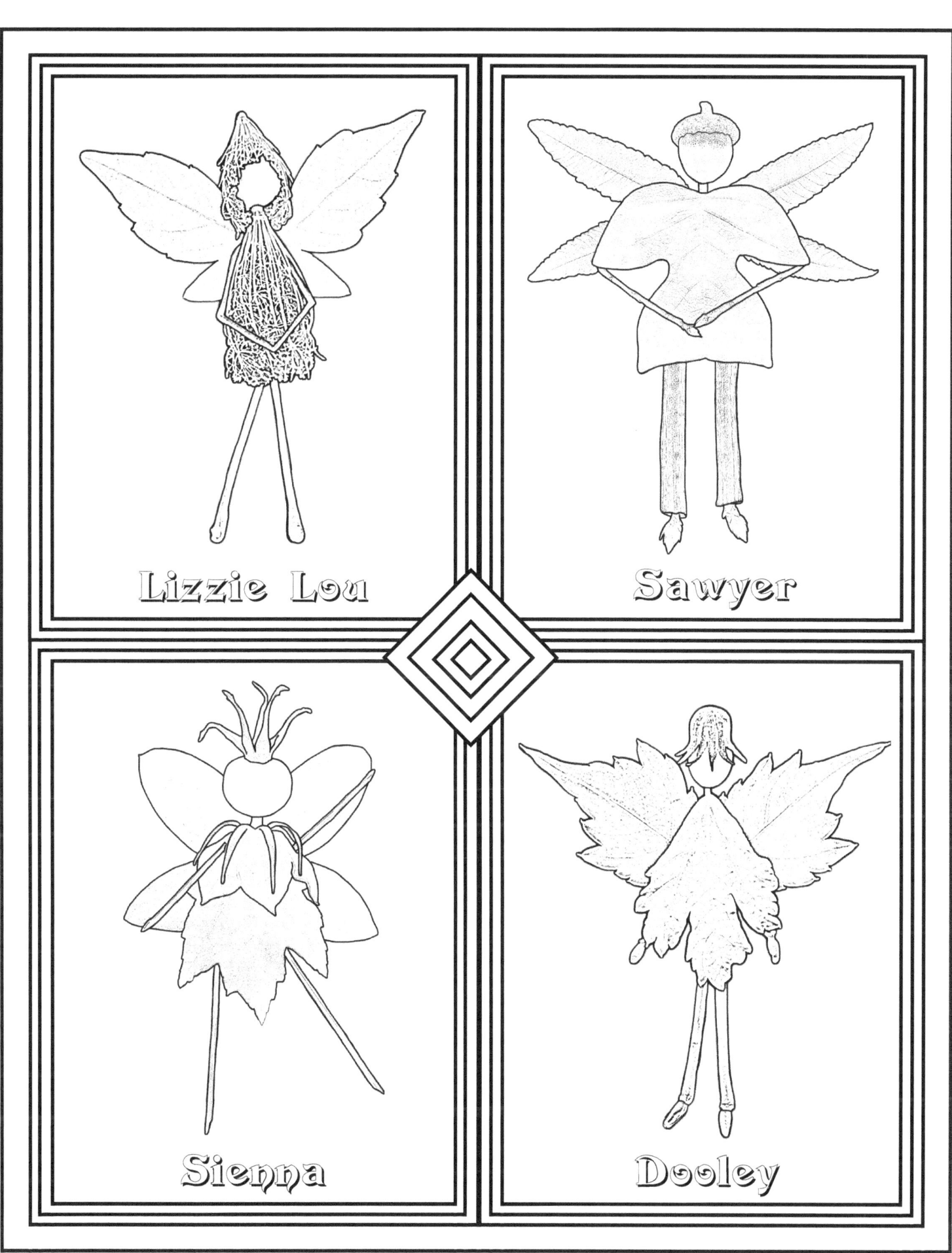

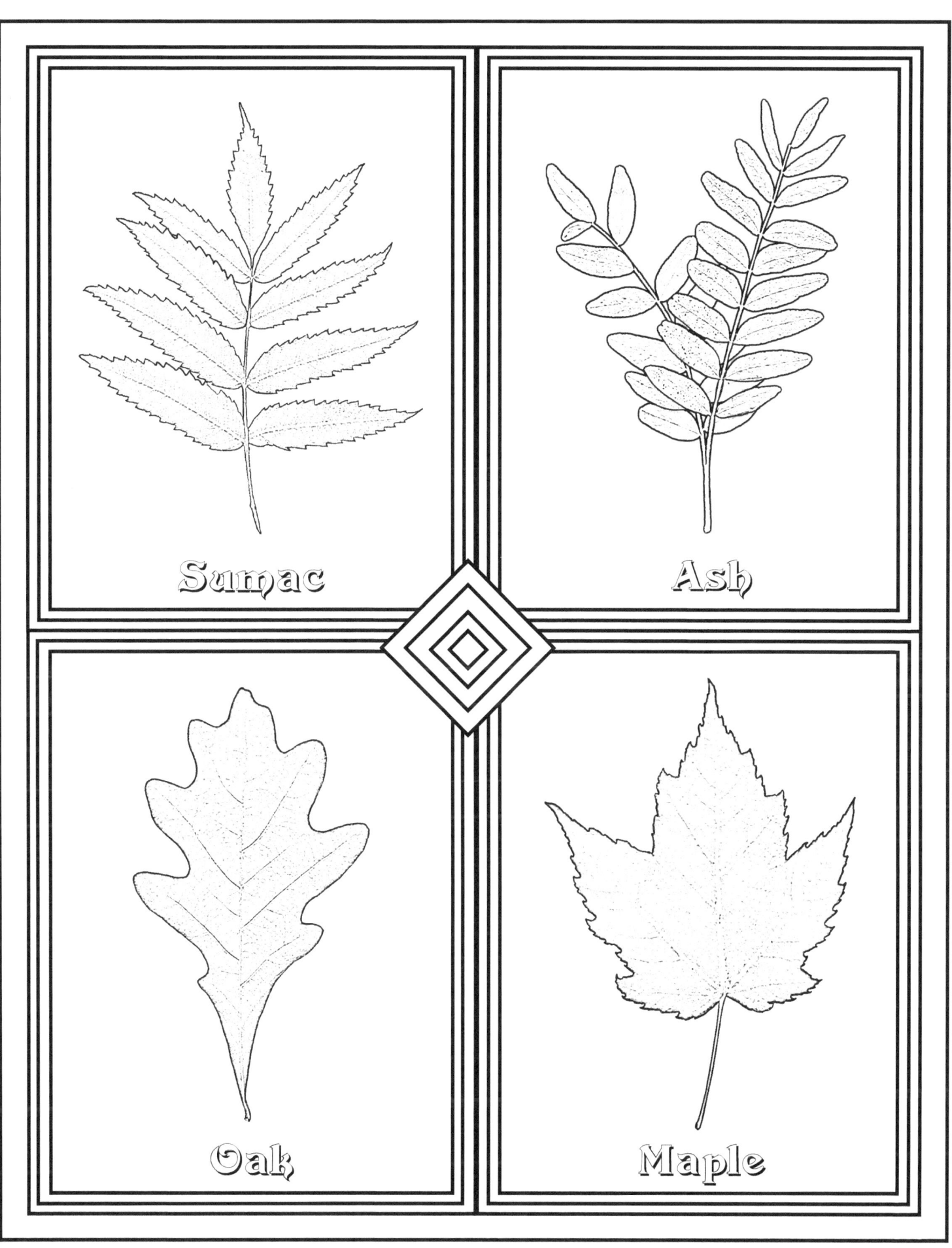

Dolly Polypore: a shelf mushroom fairy with twig legs and leaf stem arms

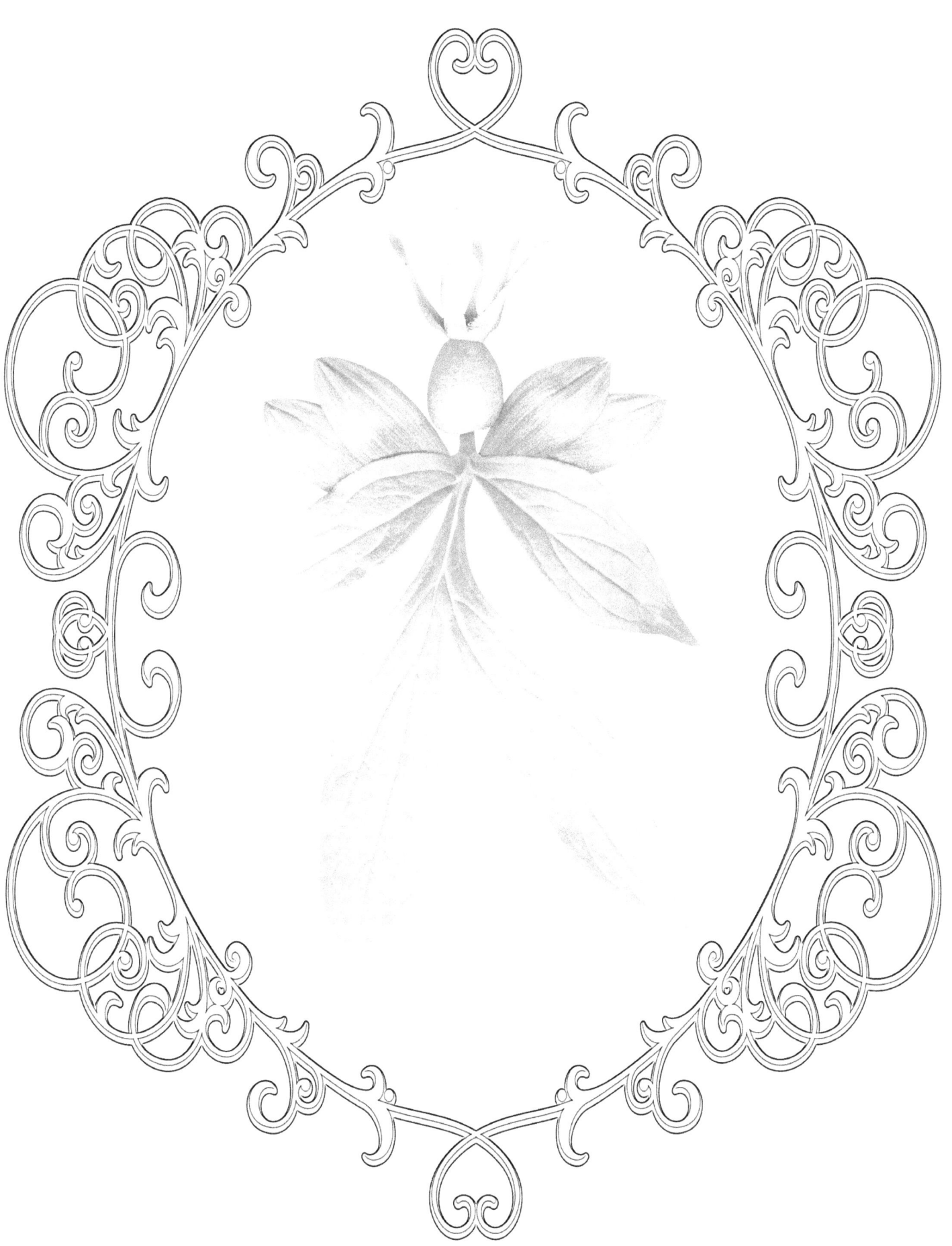

Jolly Jasper Rose-Hip Head: a changing color peony leaf body, sunflower petal wings, and of course, a rose-hip head

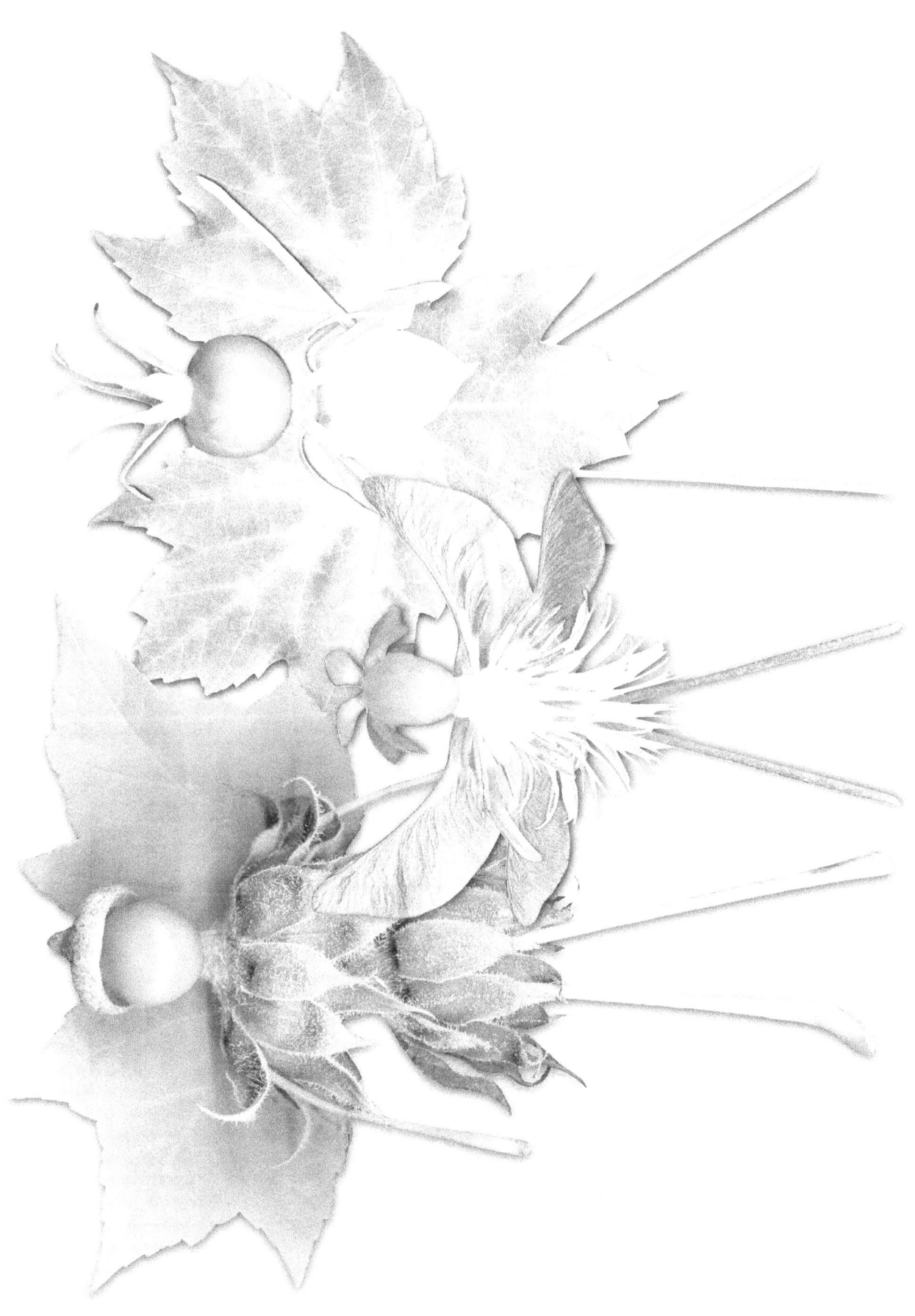

The Maple Family

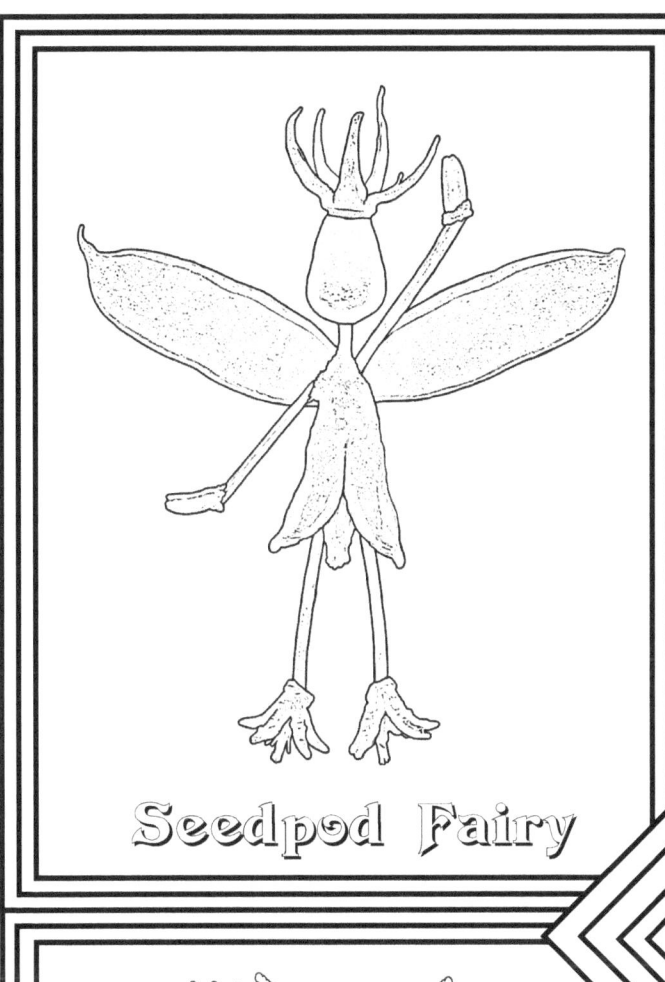
Seedpod Fairy

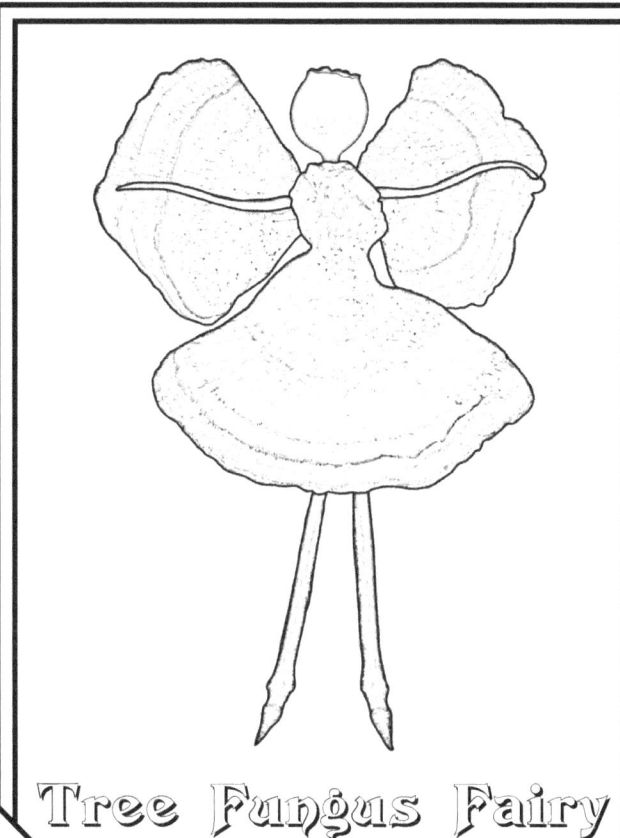
Tree Fungus Fairy

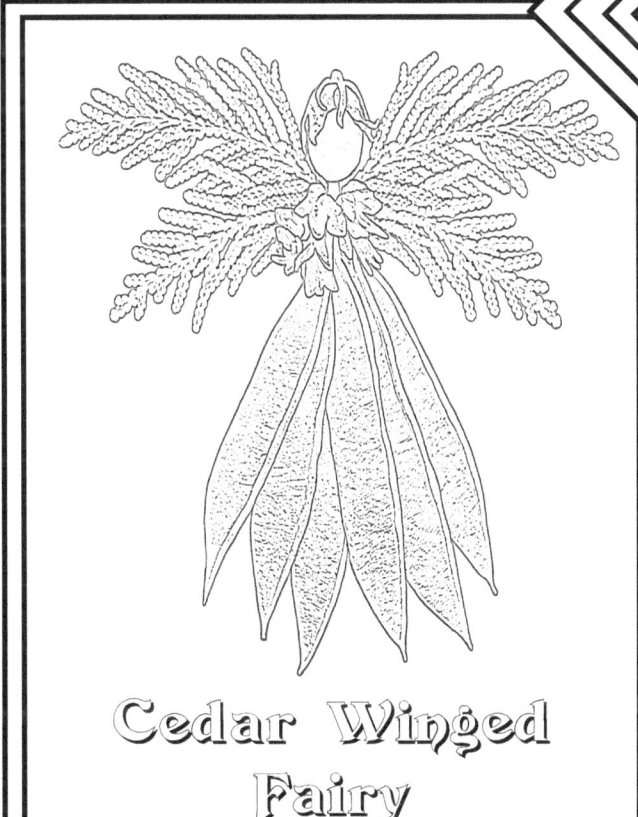
Cedar Winged Fairy

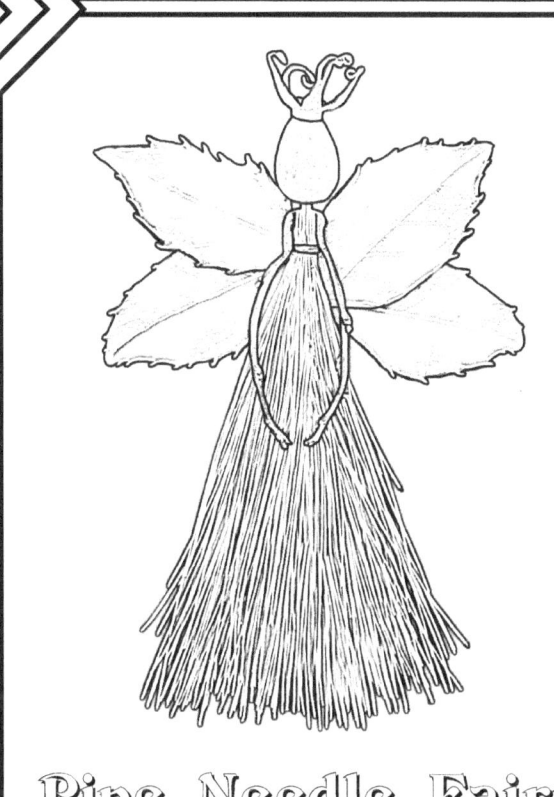
Pine Needle Fairy

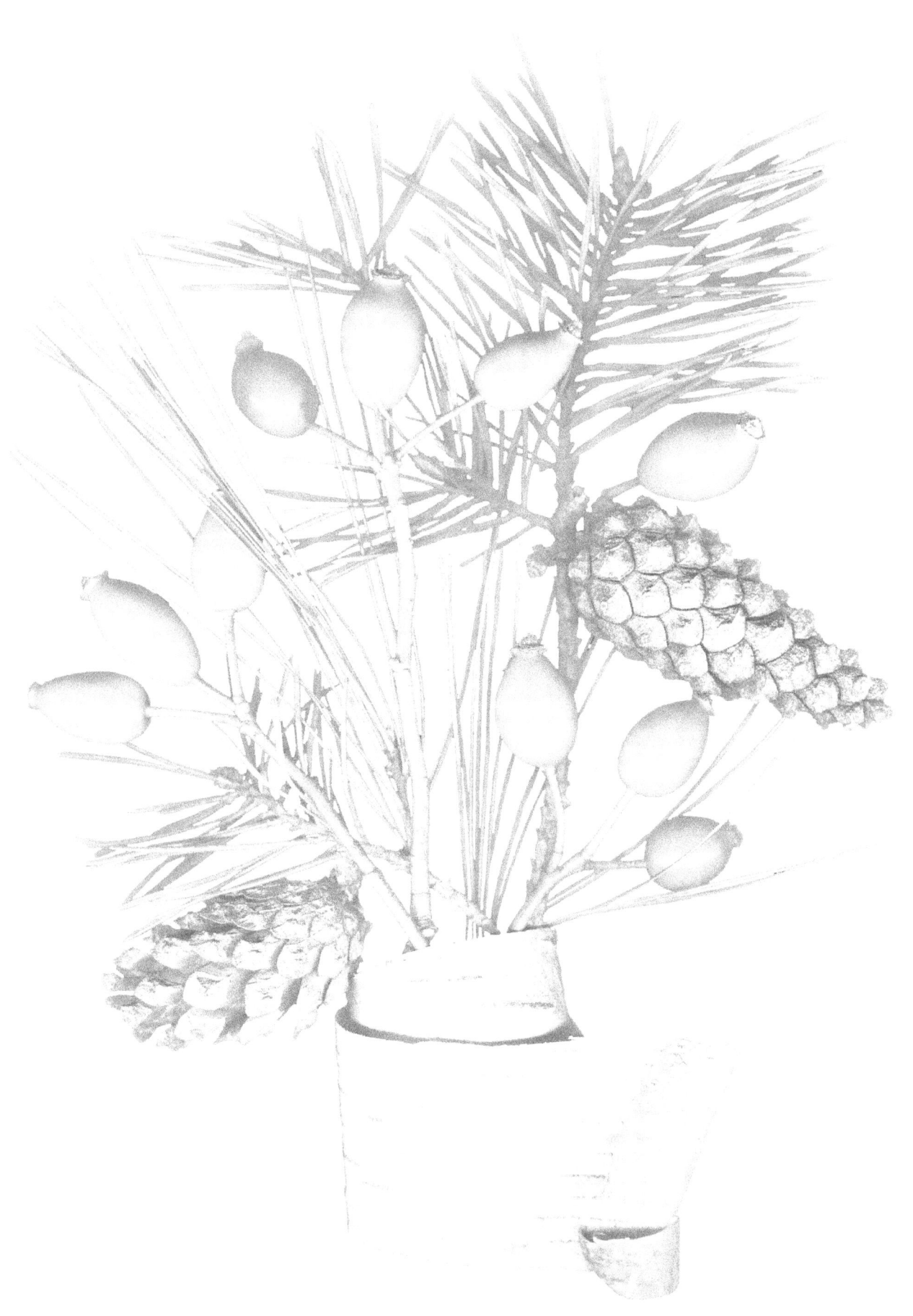

a winter arrangement with rose-hips, pine cones and needles, and white birch bark

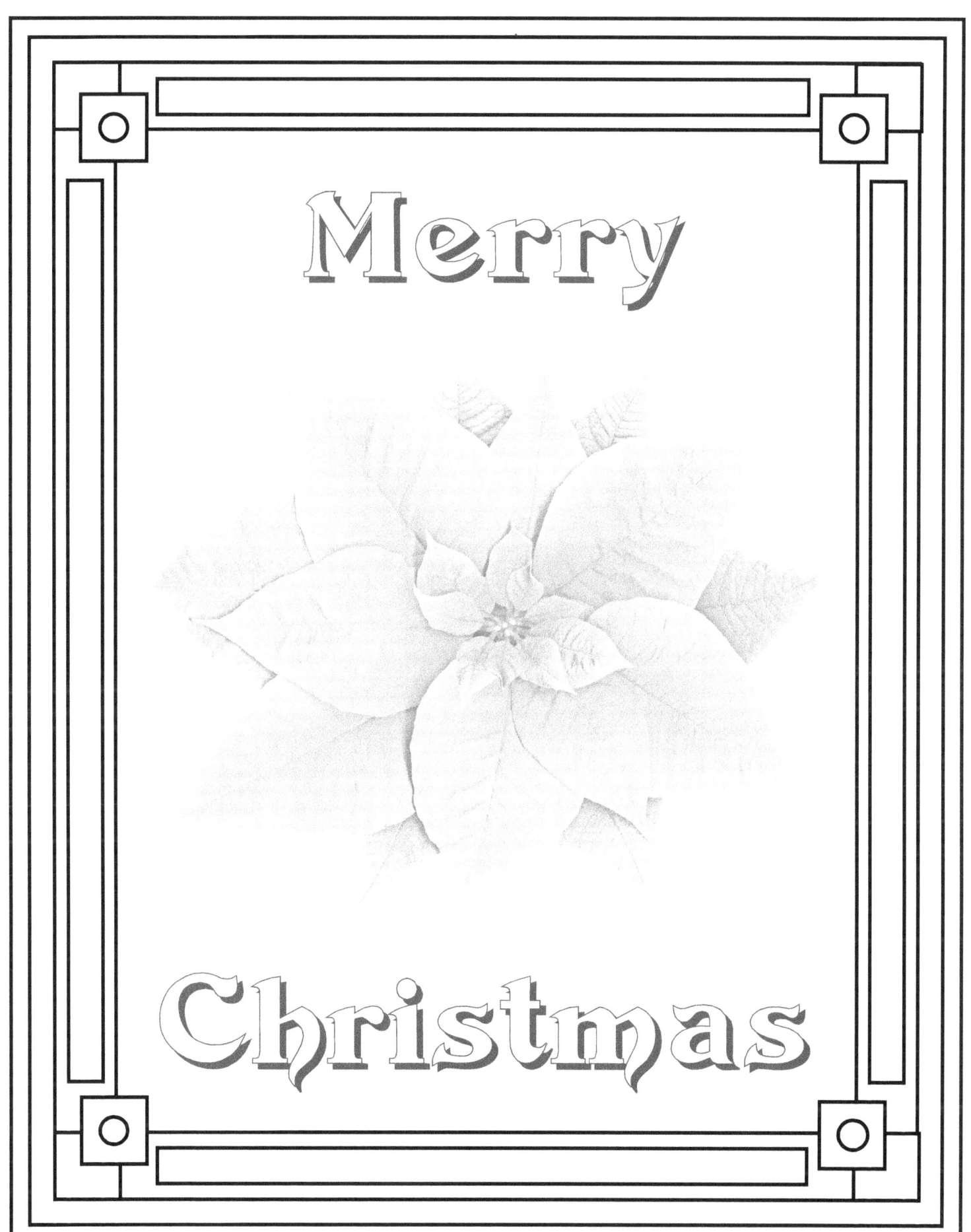

poinsettia

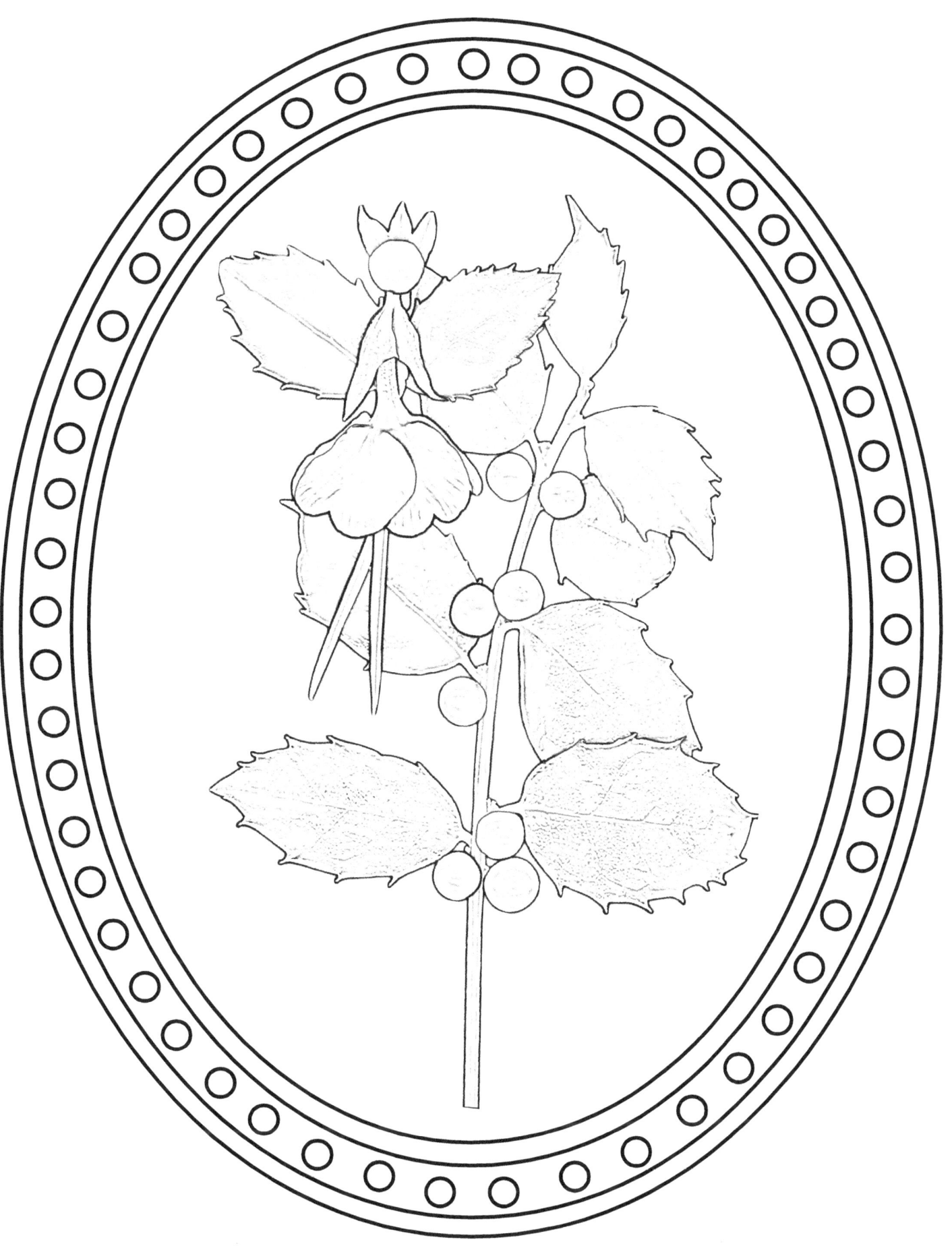

Fairy Holly Berry: wearing a primrose gown, holly berry head, and holly leaf wings, with a sprig of holly

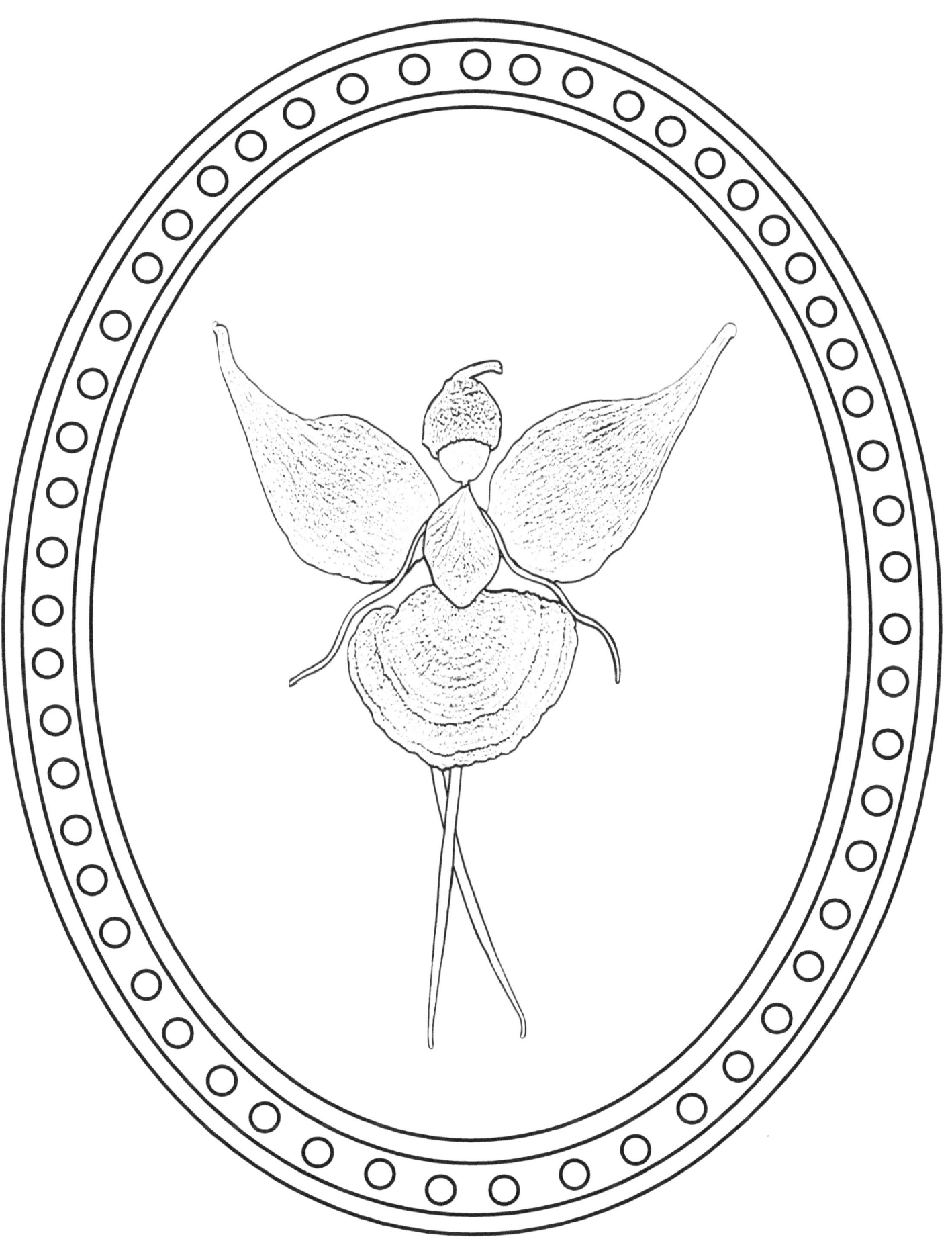

winter woodland fairy: shelf mushroom skirt, acorn head, milkweed pod wings, and dried hydrangea petal blouse

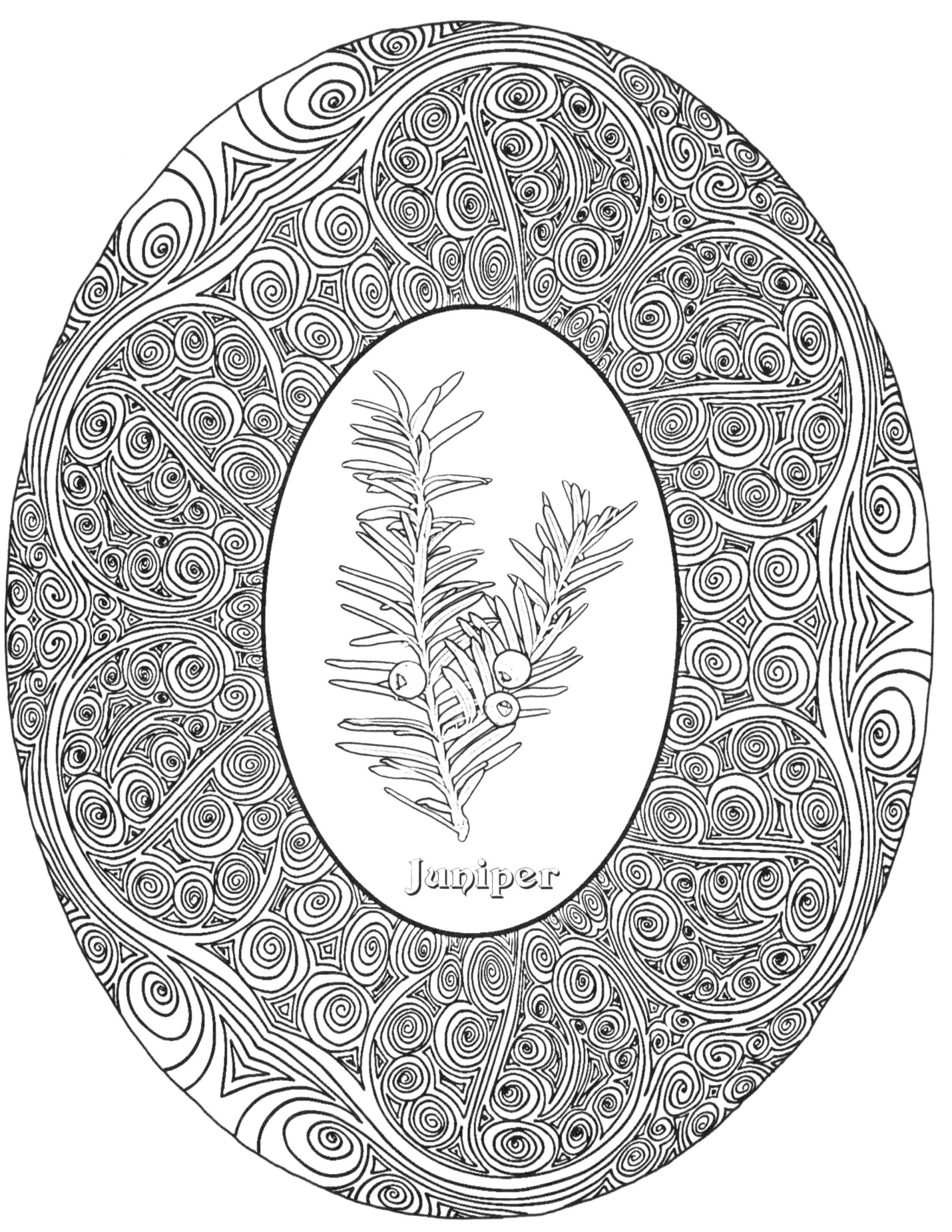

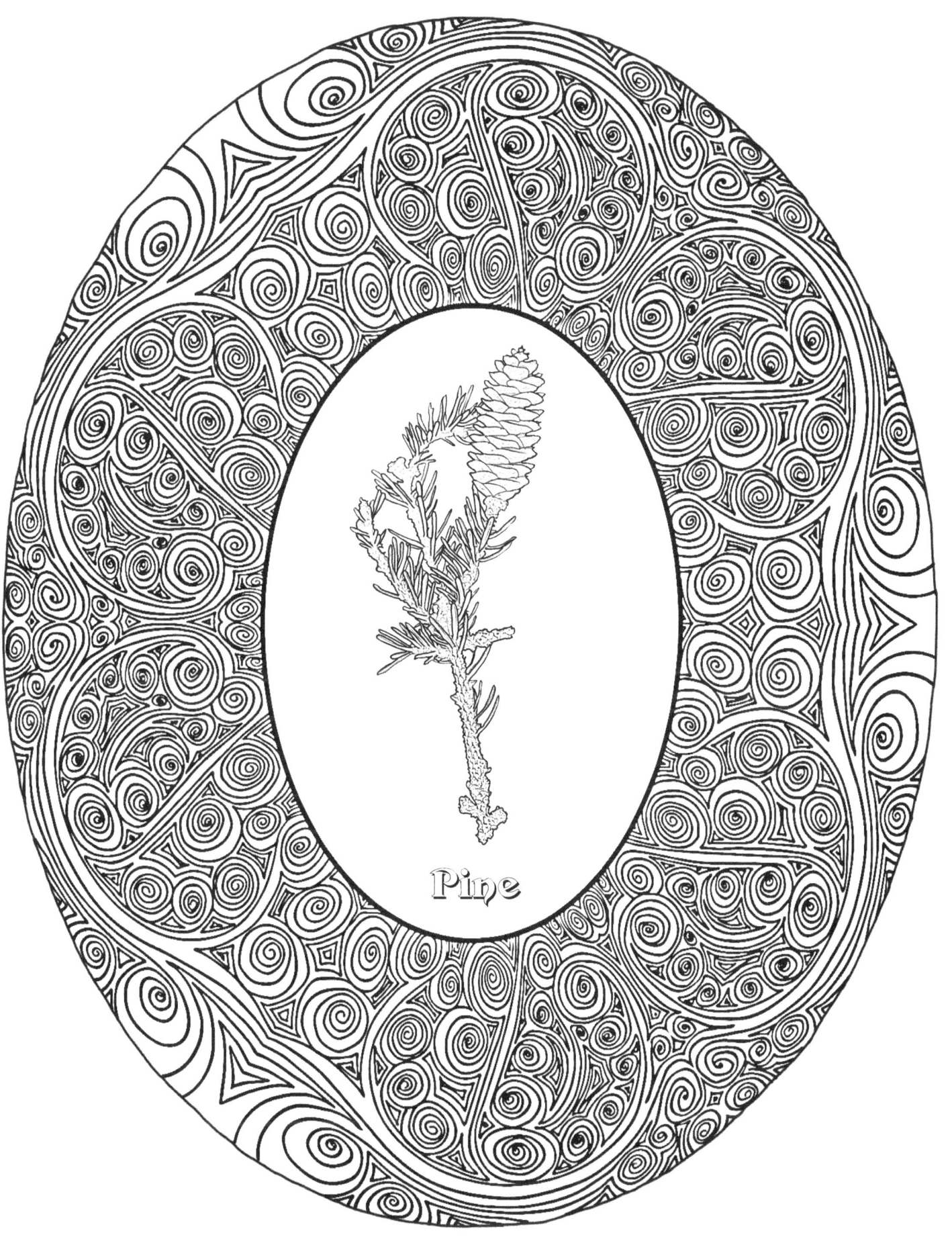

I hope you've enjoyed this book. I welcome feedback, both positive and negative. If you would like to see more or less of a particular style—grayscale versus outlined, fairies or flowers, please let me know. All comments are appreciated. You can reach me by email at :
Lrdavis@wallflowersandcards.com.

More of my digital art can be viewed at:
www.WallflowersAndCards.com.

www.ingramcontent.com/pod-product-compliance
Lightning Source LLC
Chambersburg PA
CBHW080707190526
45169CB00006B/2279